FOUNDATIONAL
CALLIGRAPHY
MANUAL

BOOKS BY ARTHUR BAKER

CALLIGRAPHY

CALLIGRAPHIC ALPHABETS

THE ROMAN ALPHABET

DANCE OF THE PEN

THE SCRIPT ALPHABET

CALLIGRAPHIC INITIALS

HISTORIC CALLIGRAPHIC ALPHABETS

CALLIGRAPHIC ORNAMENTS AND FLOURISHES

ARTHUR BAKER'S COPYBOOK OF
RENAISSANCE CALLIGRAPHY
(Mercator's Italic Hand)

CHANCERY CURSIVE, STROKE BY STROKE
An Arthur Baker Calligraphy Manual

CALLIGRAPHIC CUT PAPER DESIGNS

CELTIC UNCIAL, STROKE BY STROKE
(The Book of Kells) An Arthur Baker Calligraphy Manual

ARTHUR BAKER'S COPYBOOK OF
LATINIZED GOTHIC CALLIGRAPHY
(Roots of the Bauhaus) An Arthur Baker Calligraphy Manual

FULL COLOR PAPER AIRPLANES

SQUARE CAPITALS, STROKE BY STROKE
An Arthur Baker Calligraphy Manual

CALLIGRAPHIC SWASH CAPITALS

BRUSH CALLIGRAPHY

SPLIT PEN CALLIGRAPHY

ARTHUR BAKER'S ENCYCLOPEDIA
OF CALLIGRAPHY STYLES

THE CALLIGRAPHIC ART
OF ARTHUR BAKER

FOUNDATIONAL CALLIGRAPHY MANUAL

ARTHUR BAKER

Charles Scribner's Sons / New York

Library of Congress Cataloging in Publication Data

Baker, Arthur.
　Foundational calligraphy manual.

　1. Calligraphy—Technique.　I. Title.
NK3600.B26　1983　　745.6'197　　82-42647
ISBN 0-684-17919-9 (pbk.)

1 3 5 7 9 11 13 15 17 19　　Q/P　　20 18 16 14 12 10 8 6 4 2

Printed in the United States of America.

Introduction

The Roman capitals, *capitalis monumentalis*, are the bedrock of literacy in the Western world. The genesis of our manuscripts and printed books, the signs and symbols with which we communicate, these alphabetic symbols contain all our wisdom, knowledge, and power. Perfected in the first century B.C., these letters have a grandeur and elegance that can still be seen in the crumbling ruins surviving around the Mediterranean. For the past two thousand years these letterforms have been studied, measured, and discussed in an attempt to recreate the hand motions that formed them. Renaissance geniuses thought the letters could be deciphered and visually reconstructed with compass and square by a system of cabalistic geometry. Leonardo, Dürer, and others were wrong in their zeal. Within the past fifteen years, however, Arthur Baker, analyzing the written form of the capitals, discerned the system of strokes used to create them. His many demonstrations, in a Baker's dozen of books and in workshops, have shown the fluid ease and logic of the construction of the letterforms, the grace and beauty of the specific pen manipulations that bring these letters to life. The old has become new. A movement that can quite clearly be defined as the New Calligraphy has come into being among practitioners of the scribal art who follow Baker's methods. In fact, the movement can well be called the New American Calligraphy, for the United States has taken the lead in this new approach.

The classic Roman inscriptional capitals, or *majuscules*, and their written equivalent, the square capitals, or *quadrata*, are basic to Western letters; it should be borne in mind that the small letters, or *minuscules*, came much later. It was necessary for a long chronological progression of historical styles to take place before strong companion small letters joined the capitals. Toward the end of the tenth century and on into the eleventh, there developed at a few of the monastic centers in the British Isles a strong calligraphic (and illumination) brilliance that combined the best of the very early writing styles with the new reformed letters that had developed during the reign of Charlemagne on the continent, when the Caroline minuscules were created. At Canterbury and especially at Winchester, monks created texts of superb clarity. Strong, bold letterforms mark the surviving manuscripts.

If the Roman capitals are the bedrock of modern calligraphy—the basic point of departure—then, joined with the strong late-tenth-century minuscules, the Winchester school manuscripts should provide the strongest possible hand for study: foundational calligraphy. Edward Johnston, notably in his 1906 *Writing & Illuminating, and Lettering*, tried to reinterpret that hand for the modern student. In this attempt, however, Johnston and his disciples, although they are still a dominant influence in modern calligraphy, failed to see the most obvious feature of the

historic styles. Roman capitals and their most sensitively created stepchildren were made by a discernible stroke system, a turning of the pen and quill, a manipulation of the tools that gave them life. The English revivalists missed this manipulation of the pen, opting for strictures on holding the pen at a fixed angle, varying occasionally to another fixed angle. They entirely failed to see the fluidity and grace with which, in all periods, the most aware scribes brought letters to life. In his ground-breaking stroke-by-stroke manuals Arthur Baker has demonstrated this pen manipulation and has successfully recreated the flow of the Roman letters.

He has done so for the popular chancery cursive hand, so-called Italic handwriting; for the great Book of Kells Anglo-Irish style; and will eventually treat all the recognized historic hands. A tantalizing foretaste of this eventual feast is contained in *Arthur Baker's Encyclopedia of Calligraphic Styles*, which has 116 plates representing as many hands in strict chronology, from the classic capitals through the fifteenth-century humanistic letters.

A glance at the approach in this book is enough to whet the appetite of any calligrapher. Like all ideas reduced to communicative simplicity, it engenders an amazed "Why hasn't someone done this before?" Capital forms and then minuscules are shown A to Z, with depictions of the artist's own hand holding and moving the pen. There is no room for doubt. This calligraphy is a triumphant affirmation that "the medium is the message" (despite the denigration of some of Marshall McLuhan's ideas since his death). The combination of scholarship and artistic ability is unique. These pages are not the "writing cards" of the timid pedagogues who made early attempts at model hands, akin to the yellowing oaktag signs placed above public school blackboards through much of this century, with their forbiddingly dull demonstrations of round-hand, Palmer-method ABC's. Here is the real stuff—visualizations of historically accurate letterforms which, at the same time, reaffirm the abstract artistry of their creation. I almost hesitate to use a word that has fallen on hard times: beauty. The same striving for uniquely crafted beauty, the best one can give, that marked the work of generations of craftsmen and craftswomen—there were scriptoria of artist-nuns as well as artist-monks—and defined civilization against barbarism is here.

The pages that follow the manual of instruction—applications of the foundational hand—are a pure delight, a demonstration of the grace and style of these magnificently fluid letters. Surrender to them. Use them. To the seeker after calligraphic truth, truly useful instruction, honest craftsmanship, and artistic revelation, this book by Arthur Baker may quickly become the most cherished, dog-eared volume on your shelves. I can't think of a better fate for it.

William Hogarth

BASIC SUPPLIES
AND INSTRUCTIONS

Basic supplies:

Pens	Ruler (18″ to 24″)
Ink	Masking or drafting tape
Eraser (Magic Rub white rubber)	Selection of paper

Pens

The best beginner's pen is the Coit, in the ¼″ or ½″ width. It has a steady ink flow and makes letters large enough for the beginner to see clearly and analyze. In the instruction pages of this manual, the Coit pen is used. The nib, or point, and holder come as a single unit, in sizes from ⅛″ to 1″ and in ten split pen variations.

The Speedball broad-edged, C-series, pen point size C-O, and the Brause, point size 5 mm., are also acceptable, though smaller than ¼″. With these points you will need a pen holder. The art supply store that sells the points will probably have a variety of holder styles to select from.

"Italic" fountain pens such as Platignum and Osmiroid have the convenience of an inside inkwell but can use only water-soluble ink. They also have relatively fine points and so are not the best choice for calligraphy practice. If you wish to use one, select the largest point size available. For small calligraphy the Speedball or Brause small point sizes (C-1 to C-6 and ½ mm. to 4 mm.) are the most satisfactory.

Speedball steel brushes do not handle well for this kind of work, and the Wm. Mitchell pens are too flexible; it is better not to use them in the beginning.

Left-handers can usually find left-oblique pens or else grind right-oblique pens to a flat angle on a hard Arkansas stone, available from hardware stores. The Coit pen can be used ambidexterously because it is flat-edged.

Brause 5 mm. pen in holder

Coit ½″ pen

Speedball C-O pen in holder

Coit split pen

Coit split pen

To fill pens: For Coit pens, pour the ink into a jar to a depth of ½″ to ¾″. Dip the pen into the ink, and tap it against the side of the jar to release the excess. For Speedball and Brause pens, fill the reservoir with a dropper. Most ink bottles come with a dropper in the cap. Be careful not to overfill the pen.

To clean pens: After using pens, wipe them dry. When, after several uses, ink accumulates or clogs pens, soak the points in ammonia for a few minutes, scrub with a toothbrush (reserved for this purpose), rinse with water, and dry.

Ink

Any black ink, preferably waterproof, will work. Higgins Engrossing Ink, Pelikan Black Drawing Ink, Grumbacher India Ink, and Winsor Newton Black Drawing Ink are all excellent. Sumi ink that is already mixed with water is inexpensive and very black but will corrode pen points. Some inks—such as "extra dense" ink—contain shellac, and if you dilute them, a few drops of ammonia should be added.

Ink flows best when it is thin. If the hairlines seem thick when you are writing, the ink probably needs thinning. Some inks, like Pelikan Drawing Ink, can be thinned quite a bit, but be sure that after dilution the ink still dries solid black.

If you wish to write in color, it is best to use thinned designer's gouache, a watercolor pigment that comes in a tube. Squeeze some paint from the tube into a small dish or watercolor palette with recessed cells, and mix the paint until liquid with a brush and a small amount of water. Fill the pen with the paint, using the brush and filling the reservoir as you would with ink. Colored inks and dyes are beautiful, but colors will fade quickly if exposed to sunlight—often in a matter of days.

Work Surface

Calligraphy should be done on an inclined work surface. There are many folding drawing tables available now at very reasonable prices. These tables fold to between 2″ and 4″ deep for easy storage when not in use. The Alvin company has several fine models.

If you do not have a drawing table, it is easy to improvise a substitute. On a table you can sit at, prop a board with a stack of books under the back edge. To keep the board from slipping off the table, a thin strip of wood can be taped to the top table edge.

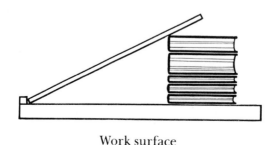

Work surface

Paper

The size and surface quality of paper for practice will depend on the size and kind of pen you are using. The Coit pen, ¼″ to ½″, is most suited to large 18″ × 24″ bond or drawing paper. A pad such as the Grumbacher "Big" Drawing Paper Pad is good. It has 100 sheets, and the sheets can be cut in half to 12″ × 18″ if you wish. The "Big" pad paper is also good for Speedball C-O and Brause 5 mm. pen practice, although for these smaller pens you may prefer tracing paper in 9″ × 12″ or 11″ × 14″ pads because it is smooth and translucent. Avoid vellum paper, which is very expensive.

Practice paper should be inexpensive enough so that you do not hesitate to use all you want. So-called calligraphy paper or papers with printed guidelines are often very costly and no better for practice than plain paper.

There are many fine papers available for finished calligraphy projects such as quotations, alphabets, poems, and posters. Grumbacher is a good white paper, but if a higher quality is desired, use 100 percent rag Bristol board, either plate (smooth) or kid (velvety) finish, 2 or 3 ply. For colored papers try Strathmore charcoal paper, Ingres or Fabriano art papers, or Crescent colored drawing papers. Crescent mat boards have the colored paper bonded to art board and may be useful for some projects. Every kind of paper has different qualities and properties, so you should experiment with all of them.

Practice Techniques

To save the time and effort of ruling guidelines on every sheet of practice paper, guidelines can be ruled in ink on one sheet that is taped on the work board. Then a blank piece of paper is taped over the ruled sheet, and you can write tracing the guidelines through the blank practice sheet. Vertical guidelines will be helpful for this alphabet; they can be placed every 1 to 2 inches. You may want to pad your drawing surface with several sheets of paper for smoother writing.

Ruled guideline sample

Holding the Pen

Hold the pen comfortably, like a pencil, with your hand as relaxed as possible. The movements of the wrist, hand, and fingers while turning the pen are unified and simultaneous. Most of the turning of the pen is accomplished by the hand and, to a lesser though significant degree, the thumb and index finger. The pen actually changes position in the hand according to the part of the letter being written, as the plates clearly show.

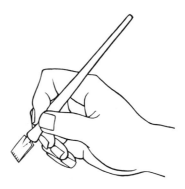

Holding the pen

The arm moves freely, especially in larger calligraphy; it is the arm that provides the direction for the stroke while the wrist and hand coordinate to make the varied thickness and quality of the line.

THE LETTERS

The basic measure of letter height is the height of the minuscule, or lowercase, x, which is called the *x-height*. The x-height of the foundational alphabet shown in the instruction plates is $4\frac{1}{2}$ times the width of the pen used to write it. The length of the ascenders and descenders in this alphabet is $2\frac{1}{2}$ pen widths, while the height of the majuscule, uppercase or capital, letter is less than the height of the ascender. It is 6 pen widths high from the baseline, and the capital proportion is independent of the minuscule—that is, the center of the capital falls below the upper x-height line.

While the instruction plates and sample alphabets in the ruled boxes hold to the ratio of $4\frac{1}{2}$ pen widths to minuscule and 6 pen widths to majuscule, this should not be regarded as a hard and fast law of this alphabet style. The art plates at the end of this book freely interpret the foundational alphabet character into different weights, or different pen-width to x-height ratios. These variations show the endless design possibilities inherent in this alphabet.

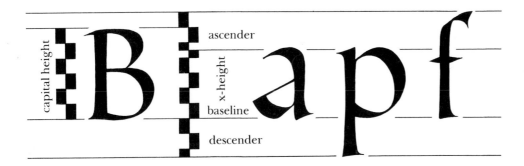

Spacing

In written words every letter should seem to be exactly in the middle of the letters to its left and right. This is often an optical judgment, as in the word *quick* from the sample quotation. The placement of the *u* is fairly obvious, but the *c* has a curve on the left and a large opening to the right. The solution is to place the *c* so that the *i* falls optically exactly between the *u* and *c*, with the curve of the *c* closer to the *i* than the space between *u* and *i* because the spaces above and below *c*'s left side are open. The serif of the *i* is drawn up to touch the *c* to help close the space between them. The *k* is placed very close to the *c*, and the bottom stroke of the *c* is brought up to touch the *k*, optically closing the *c* and making *quick* read evenly.

quick

The word *brown* shows several letters touching—*ro, ow, wn.* Letters touch in words when you feel they should unite or close a space, such as in *over* and *lazy,* but this should not be forced—for example, the *ox* in *fox* does not touch. It is better with this alphabet not to touch two vertical letters, such as the *ui* in *quick* or the *ju* in *jumps.* However, a letter with a crossbar, such as *t* or *f,* may touch both curved and vertical letters, as in *the* and *fox.*

brown·fox

Word spacing

Try to envision a whole word before you write it to anticipate places where spacing might be a problem. Letter spacing should be constant throughout a piece of calligraphy. While writing check back every few minutes to the first words in a piece to monitor the letter spaces and keep them consistent.

The spaces between words should be roughly the width of the inside, or *counter,* of the minuscule *o.*

Numerals

The numbers are similar to the letters in their calligraphic execution. The numeral *1* is similar to the minuscule *i,* though taller; the zero is like the *o;* and so on.

1234567890

THE QUICK BROWN FOX JUMPS OVER THE LAZY DOG

The quick brown fox jumps over the lazy dog

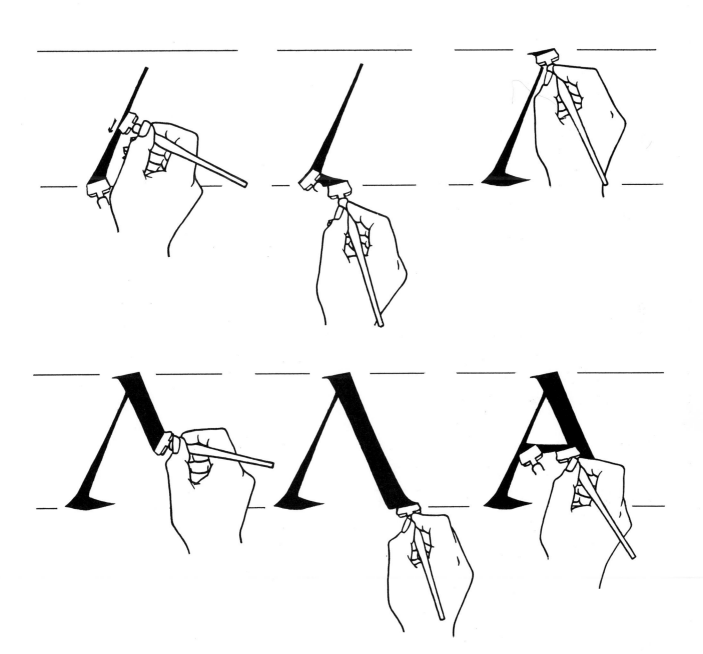

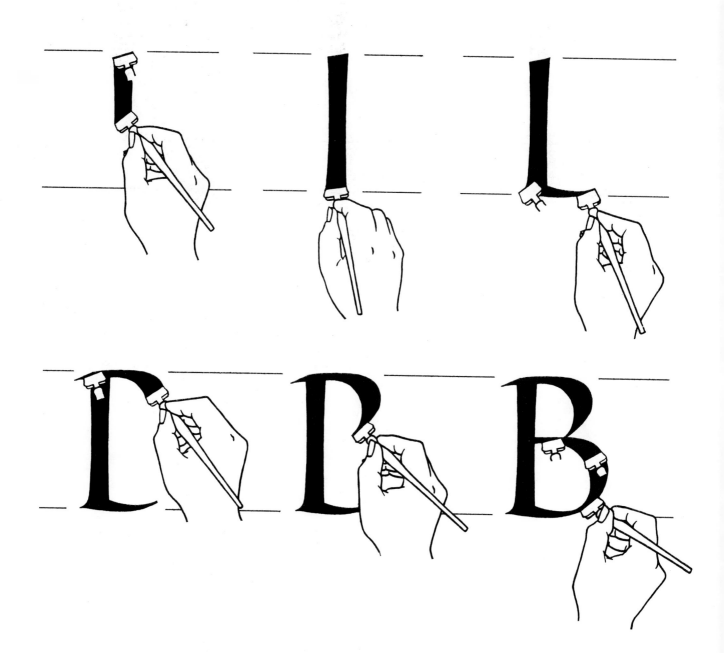

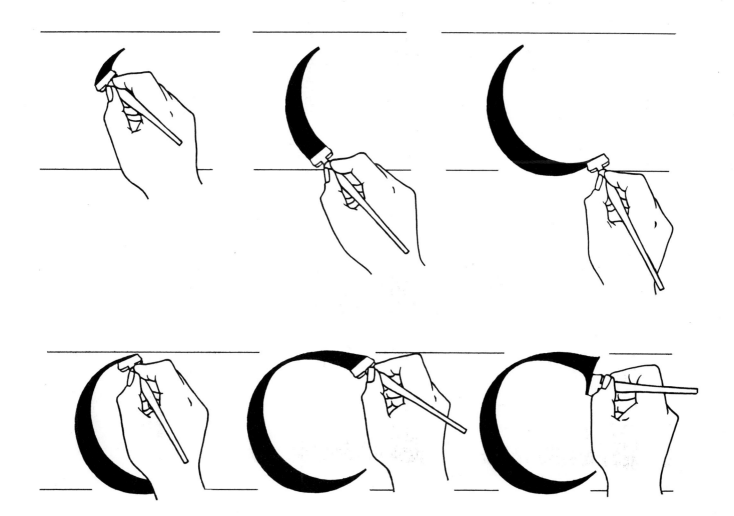

D

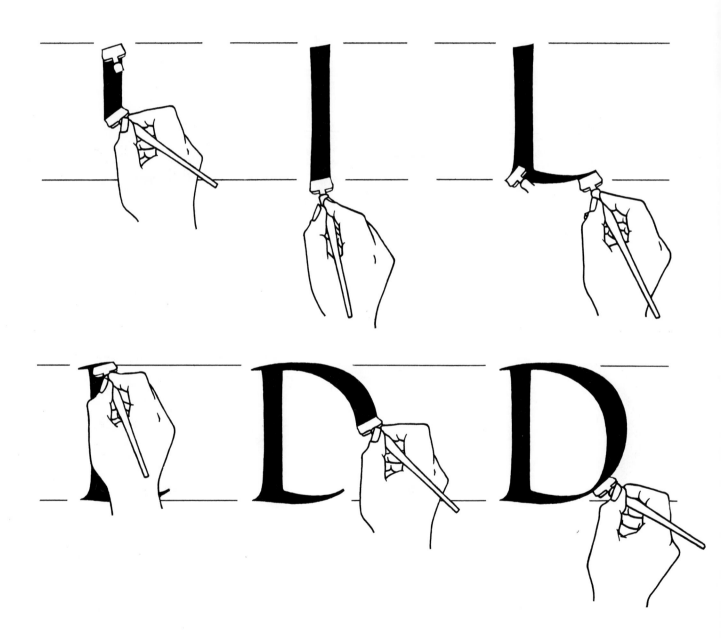

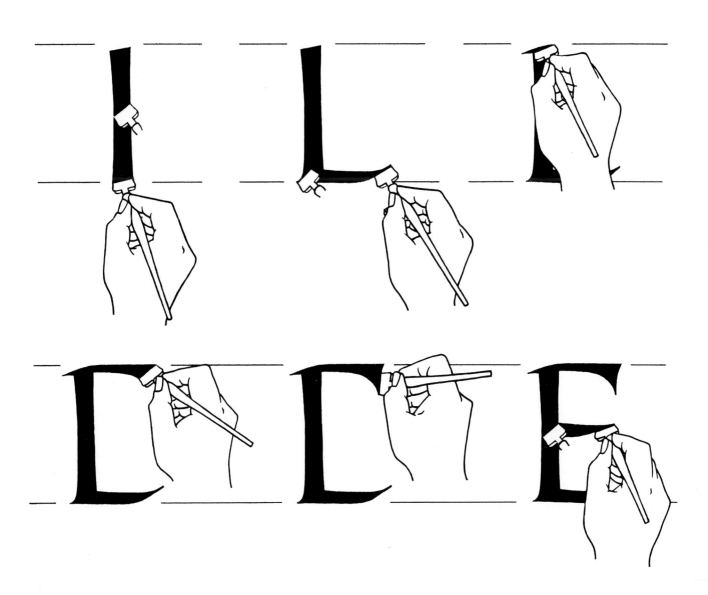

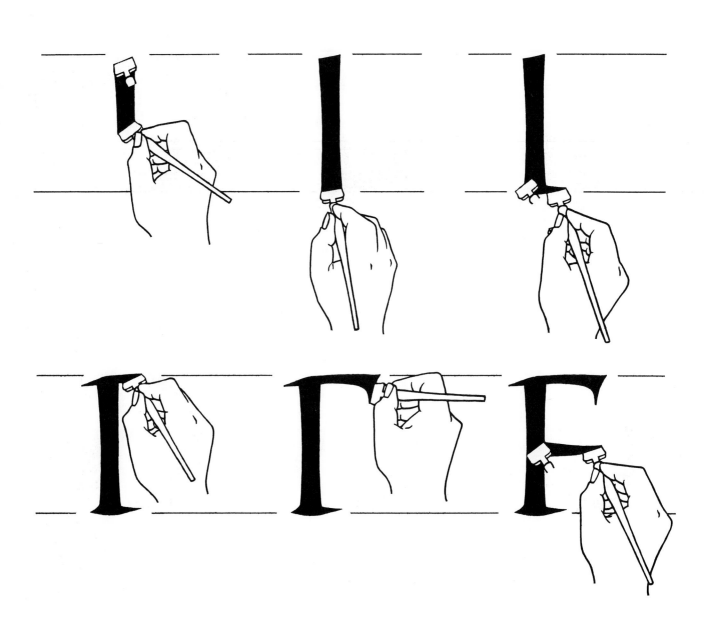

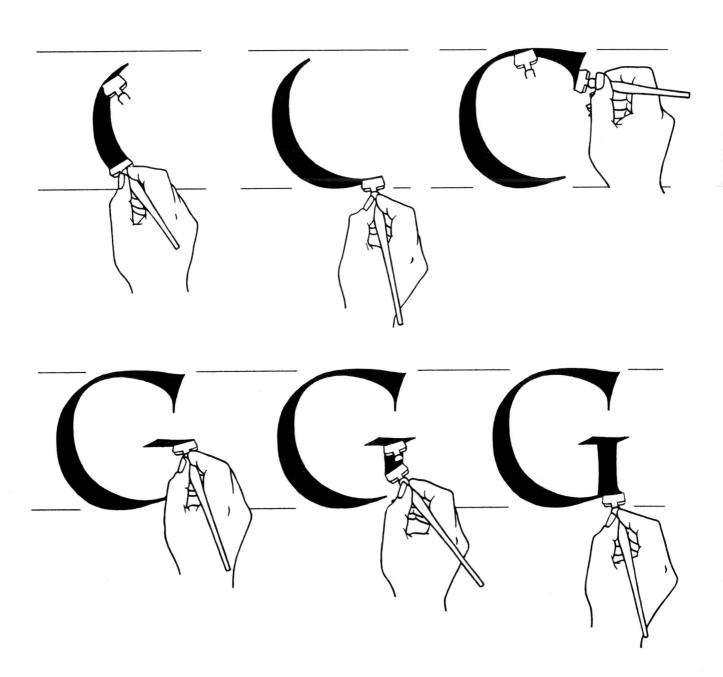

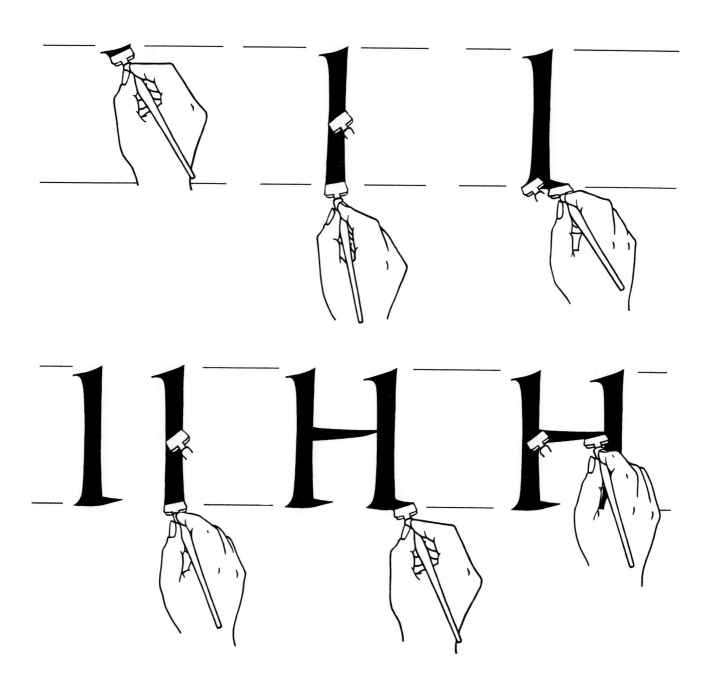

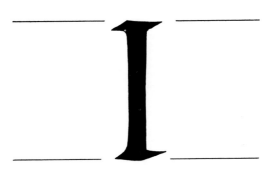

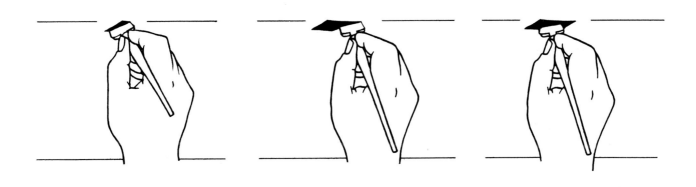

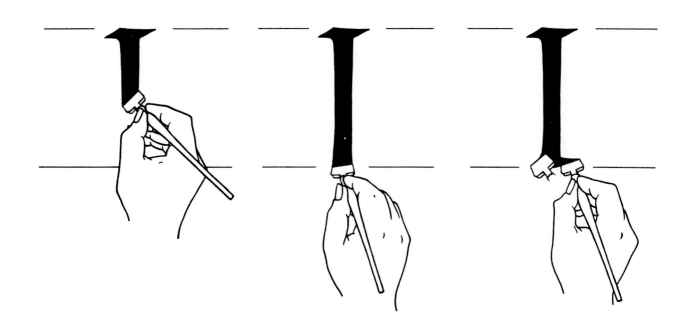

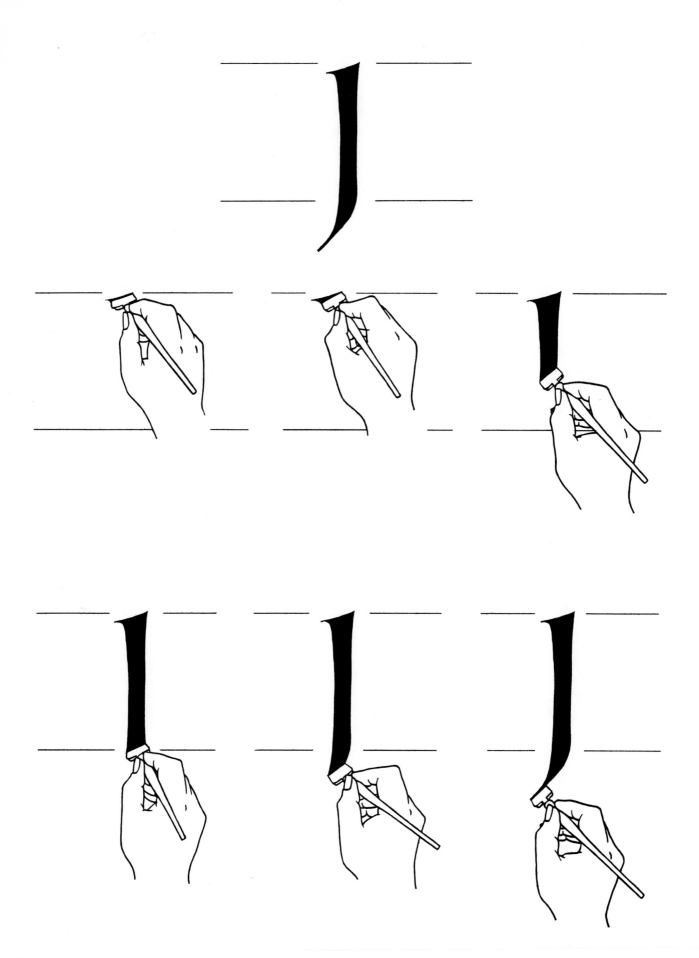

K

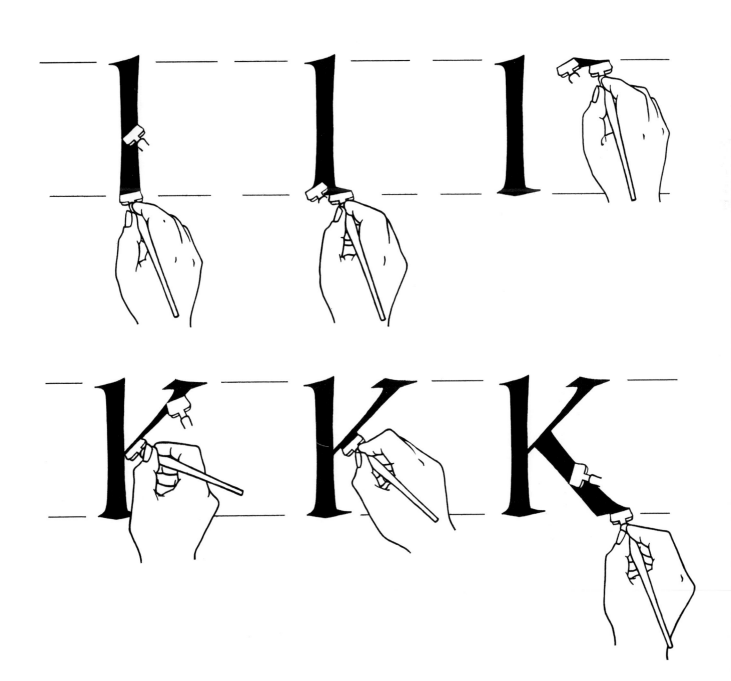

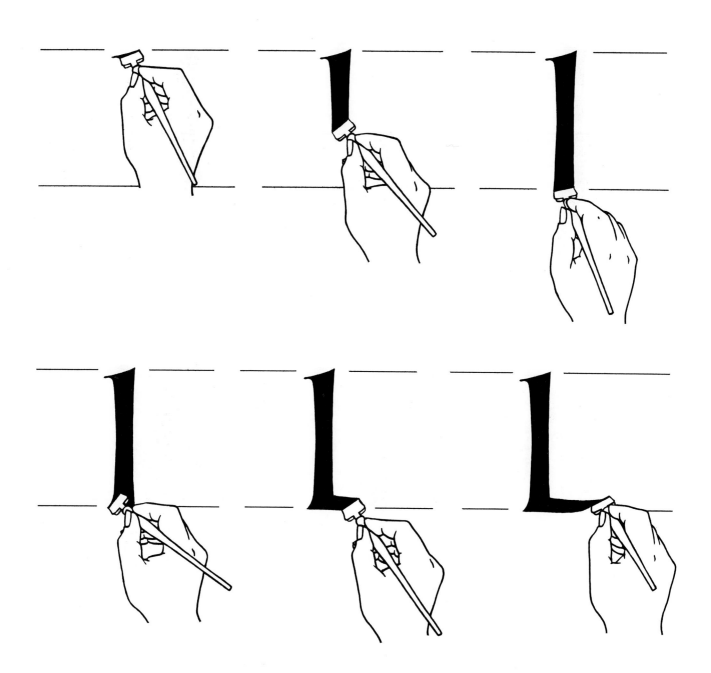

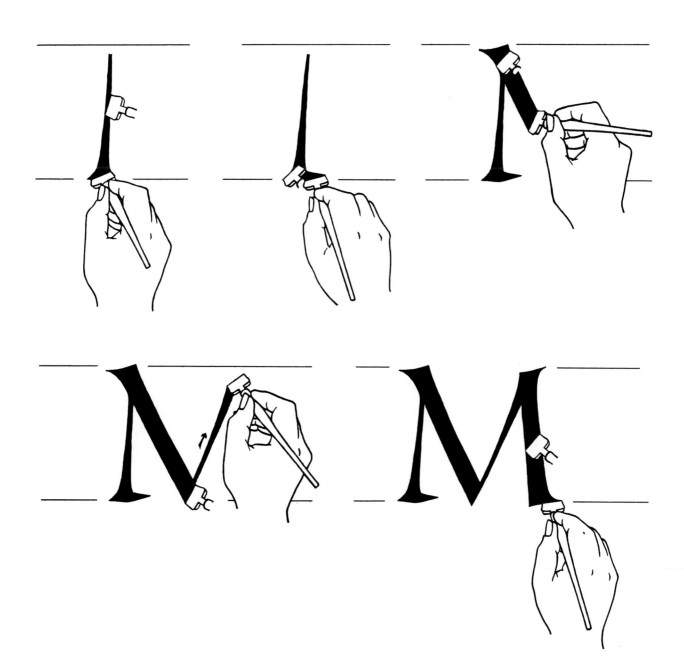

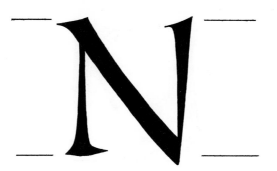

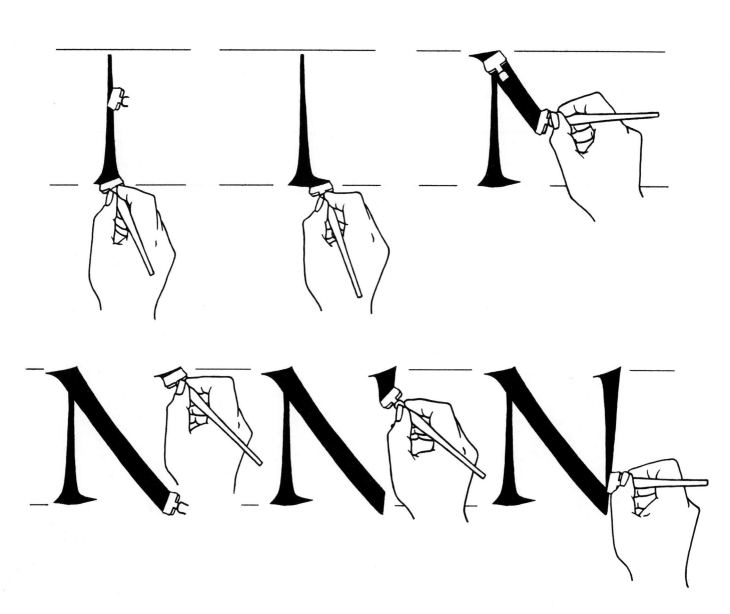

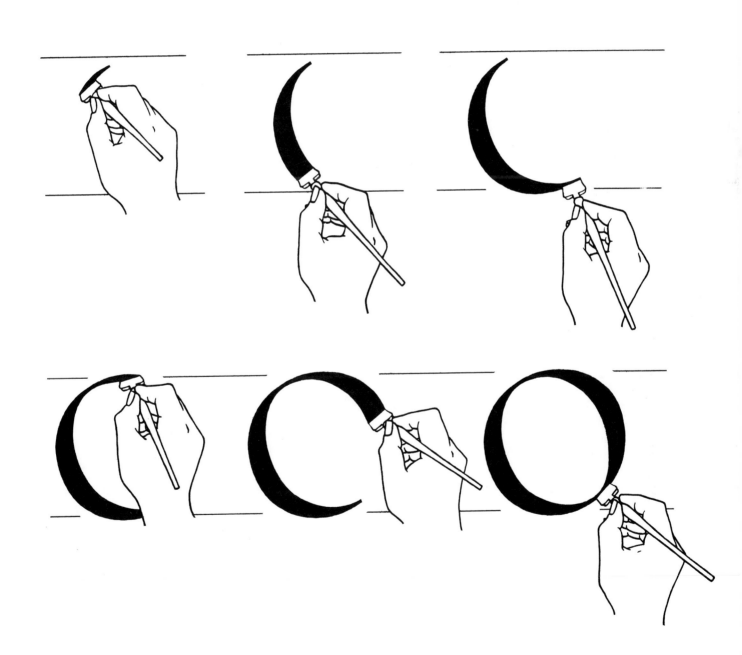

P

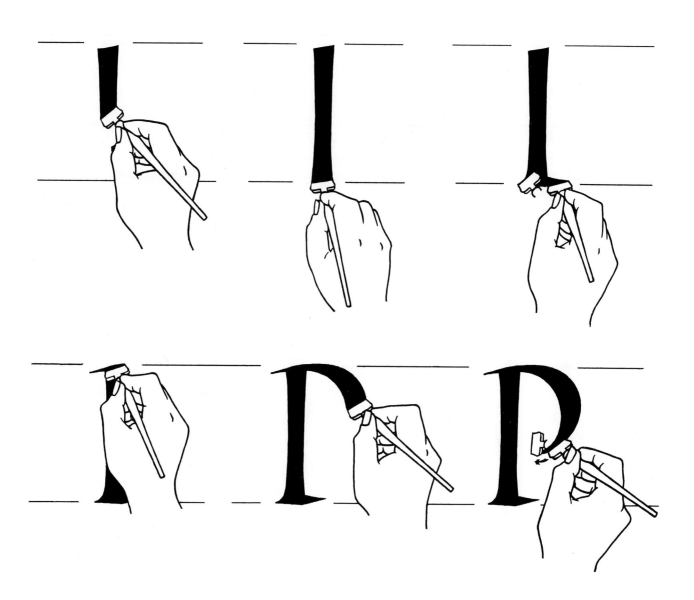

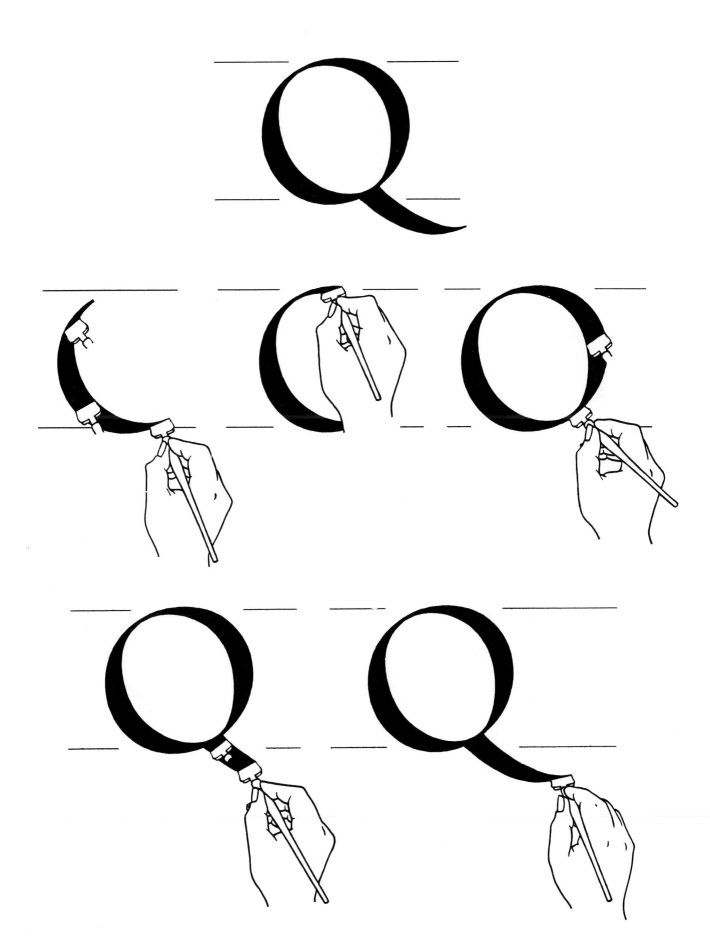

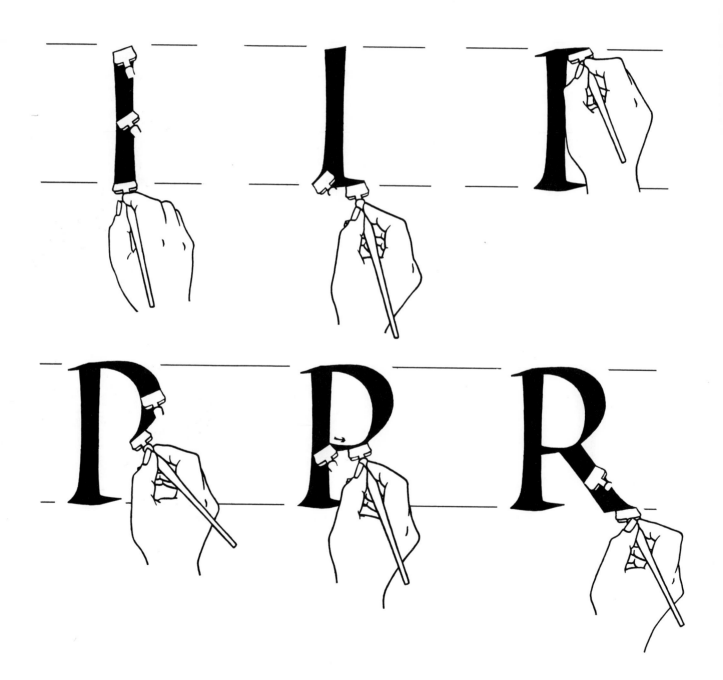

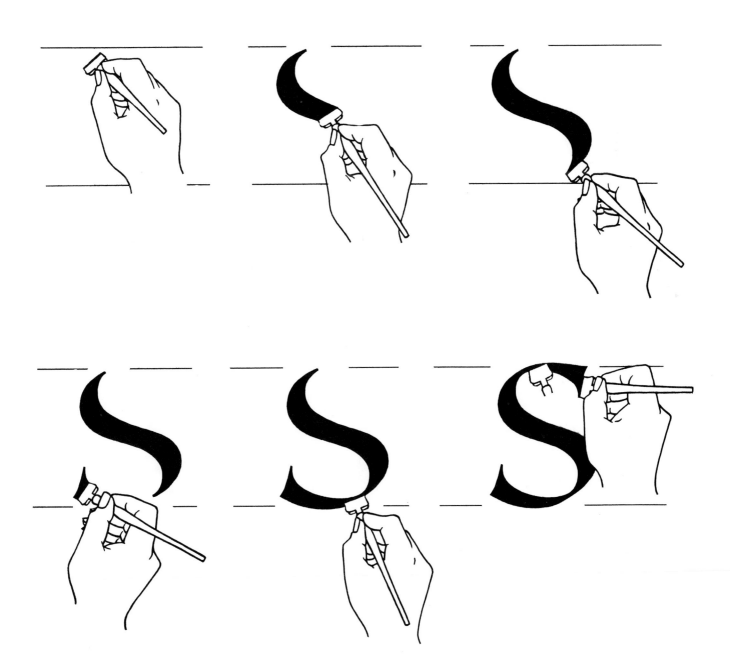

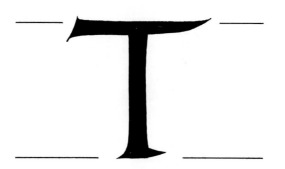

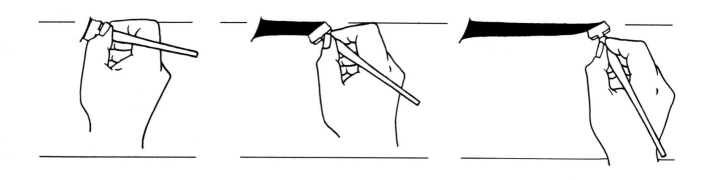

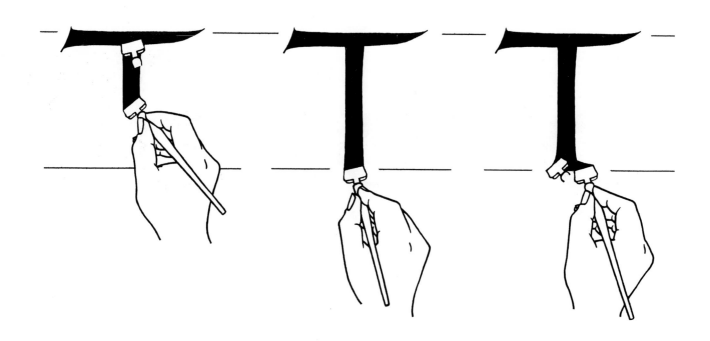

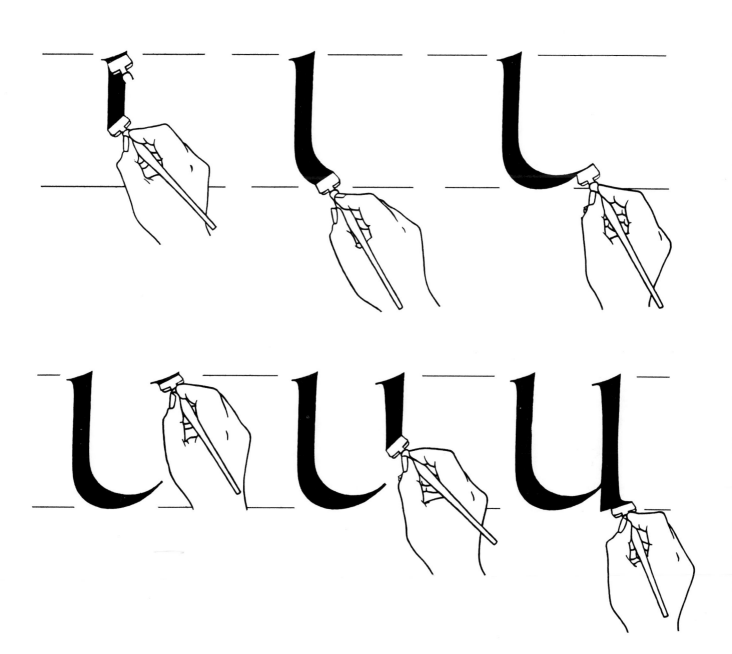

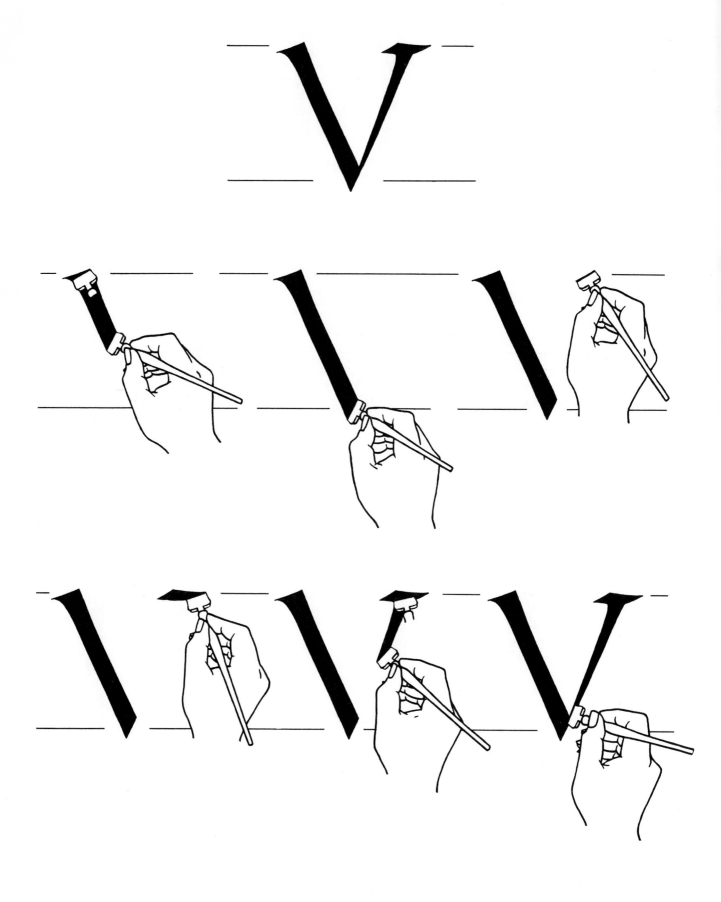

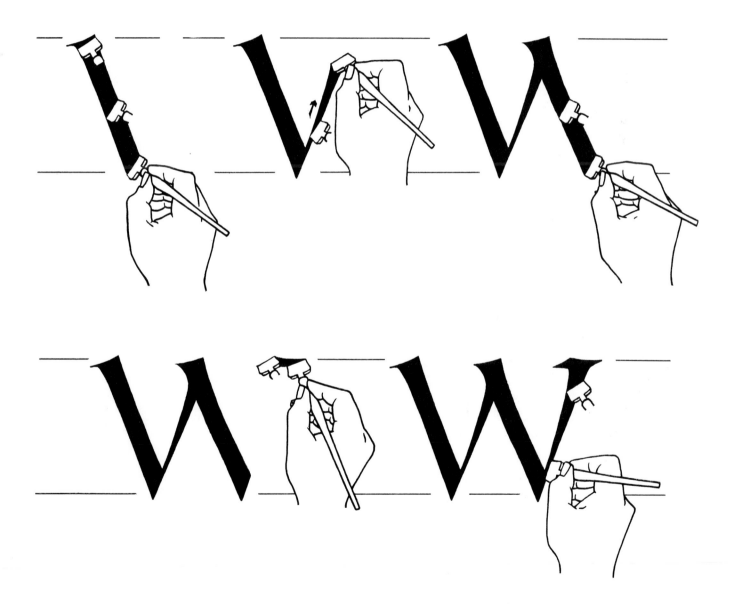

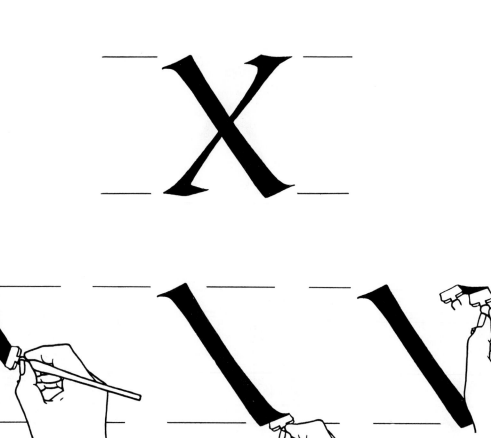

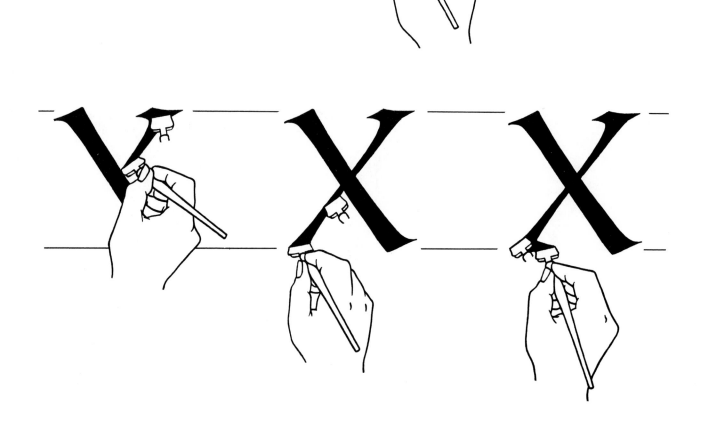

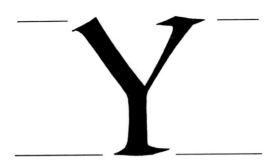

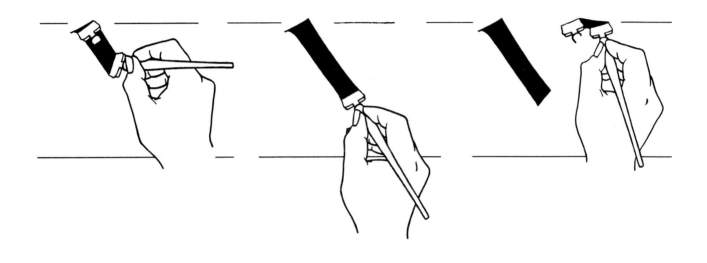

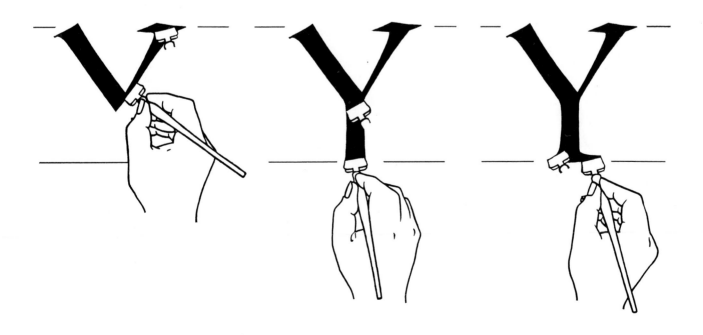

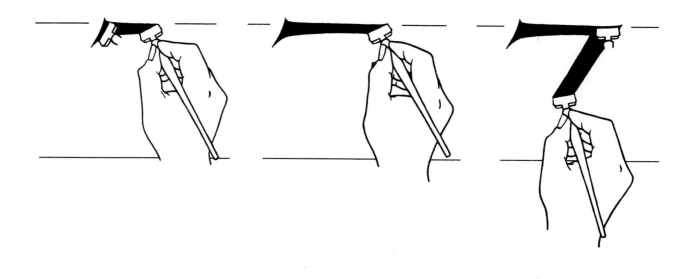

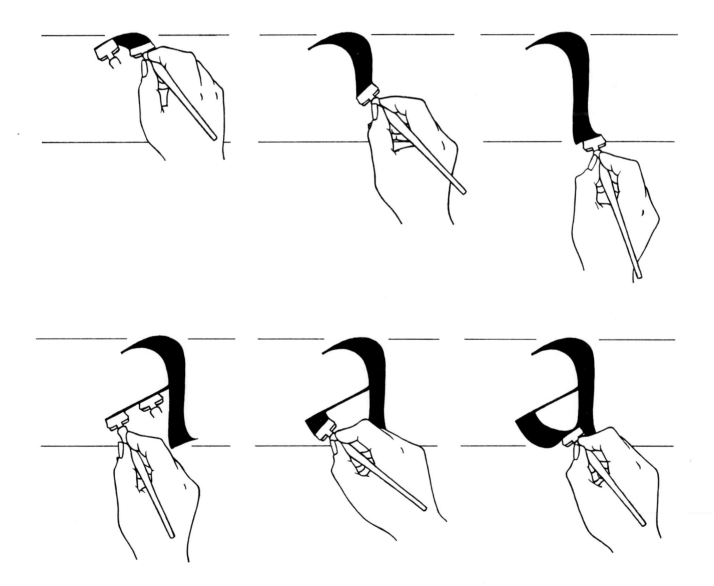

b

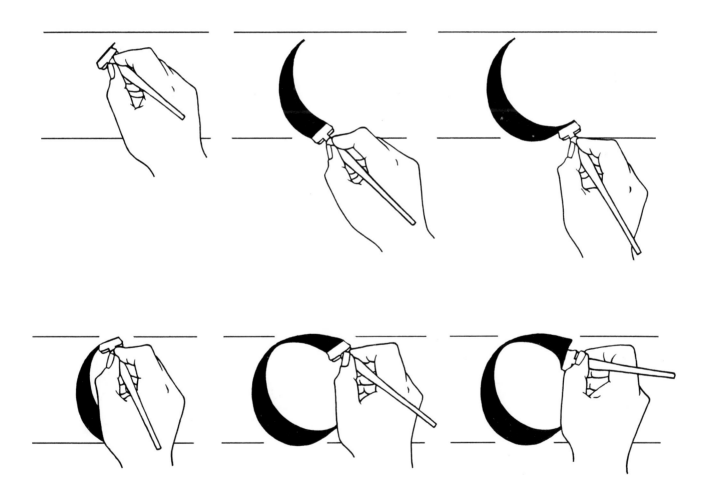

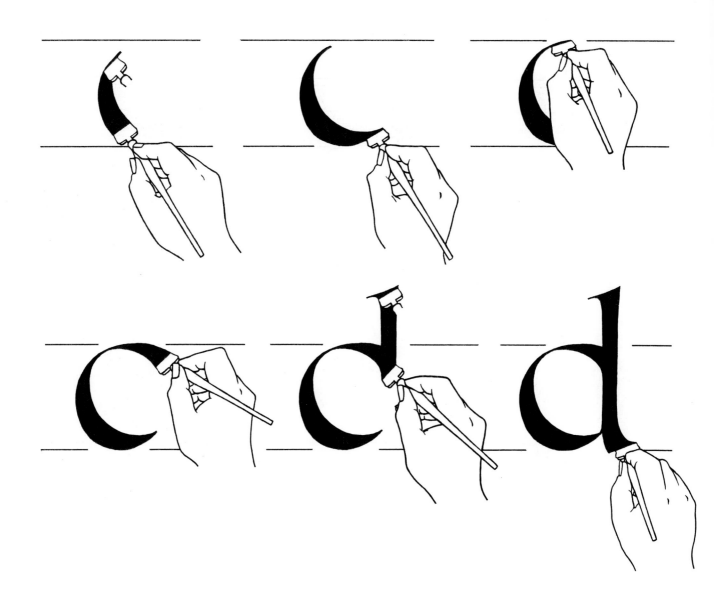

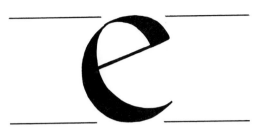

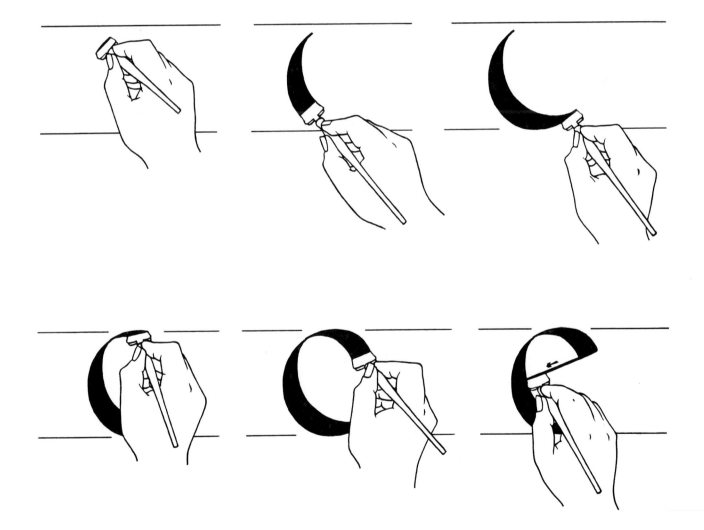

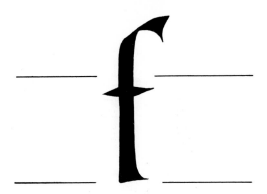

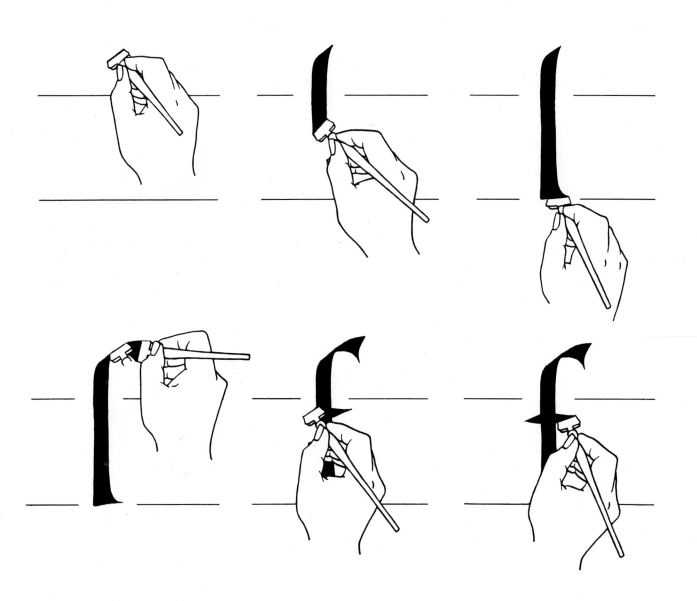

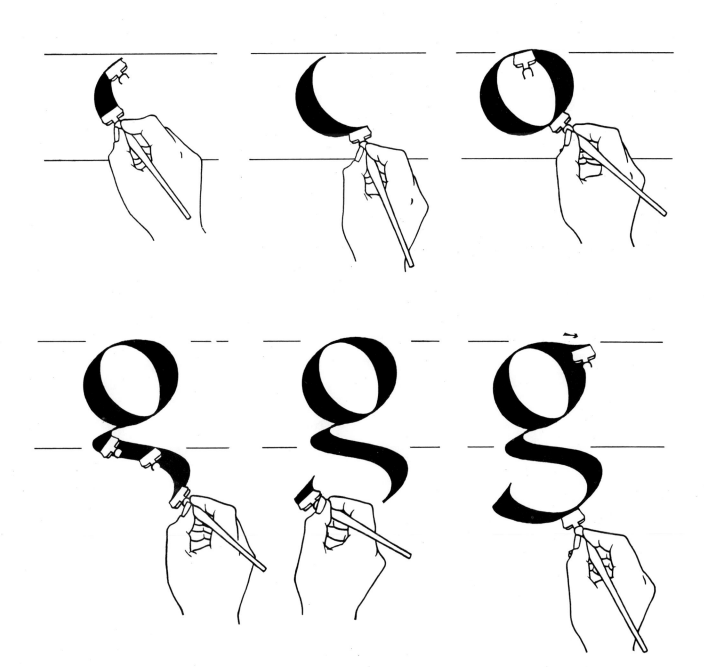

h

i l l

h h h

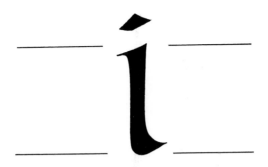

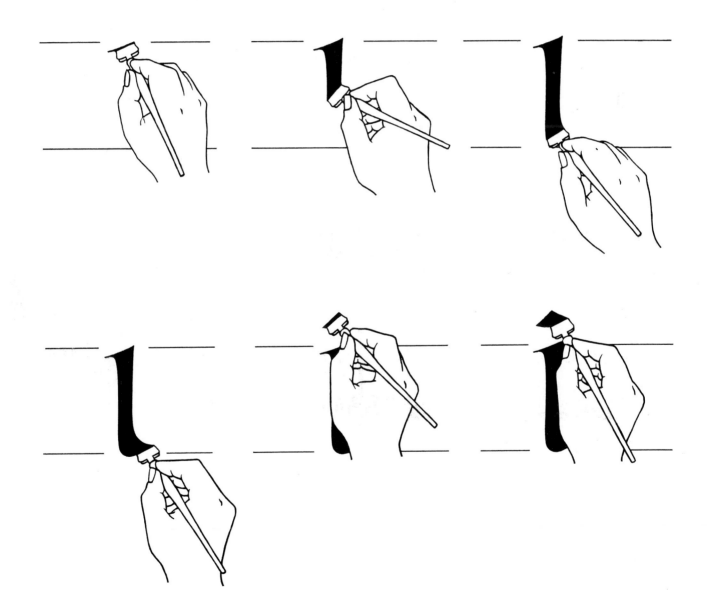

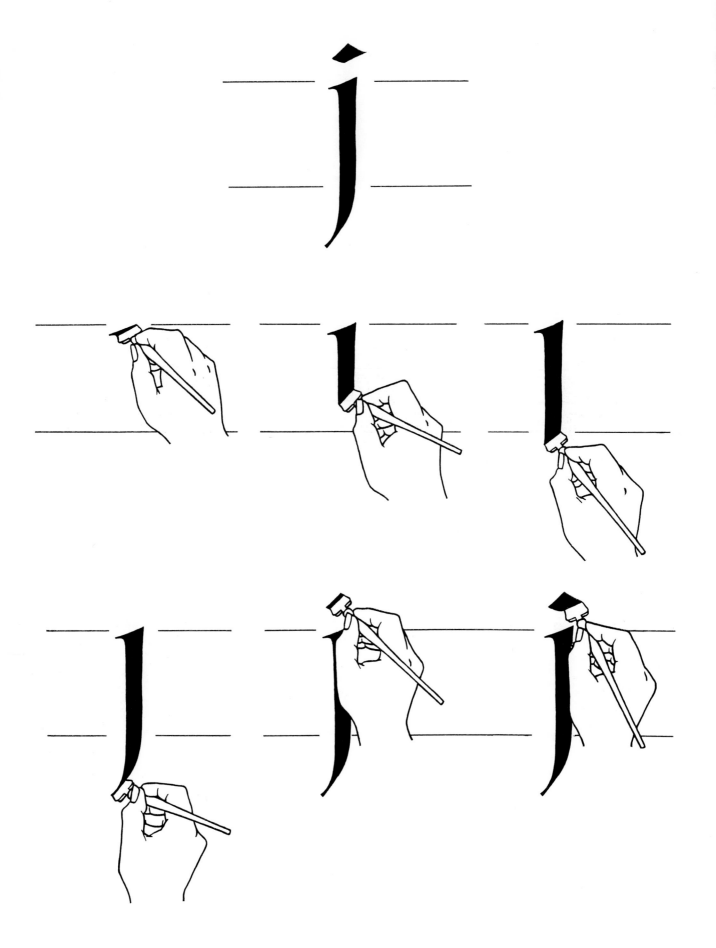

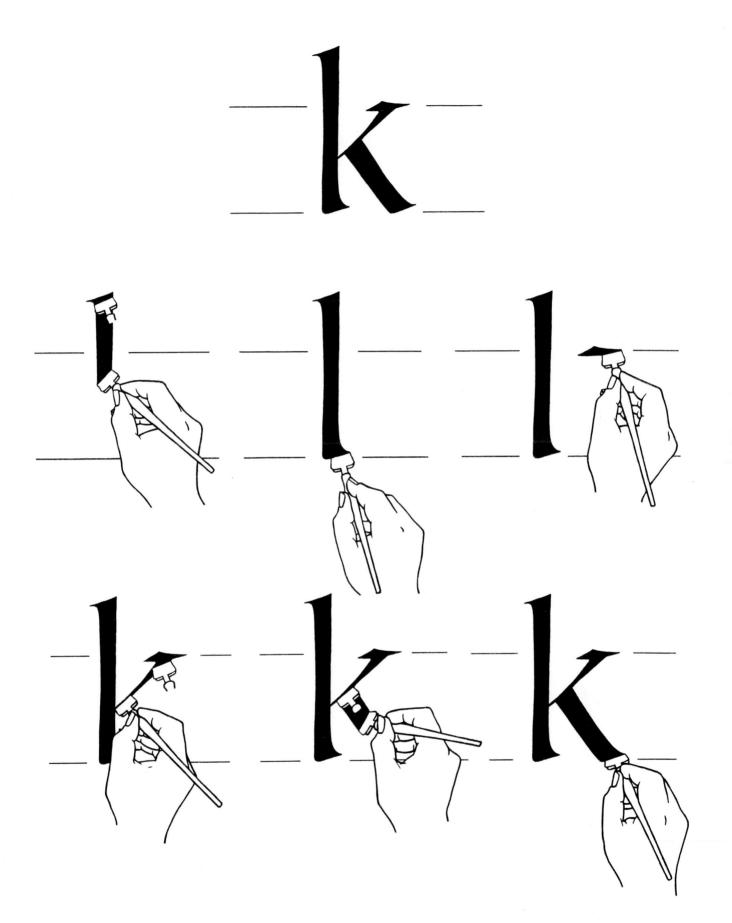

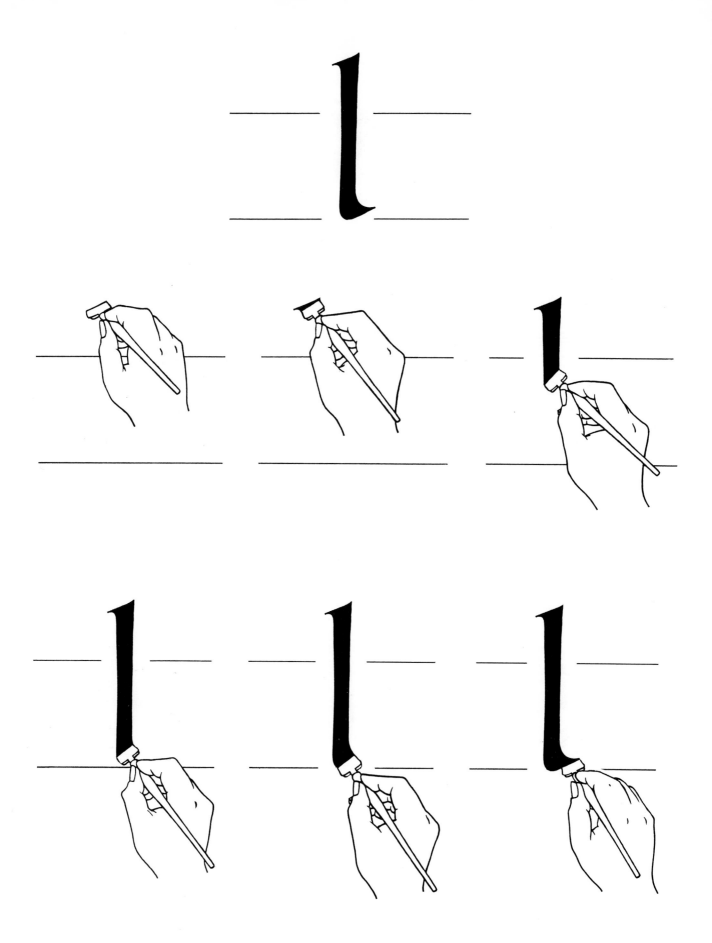

m

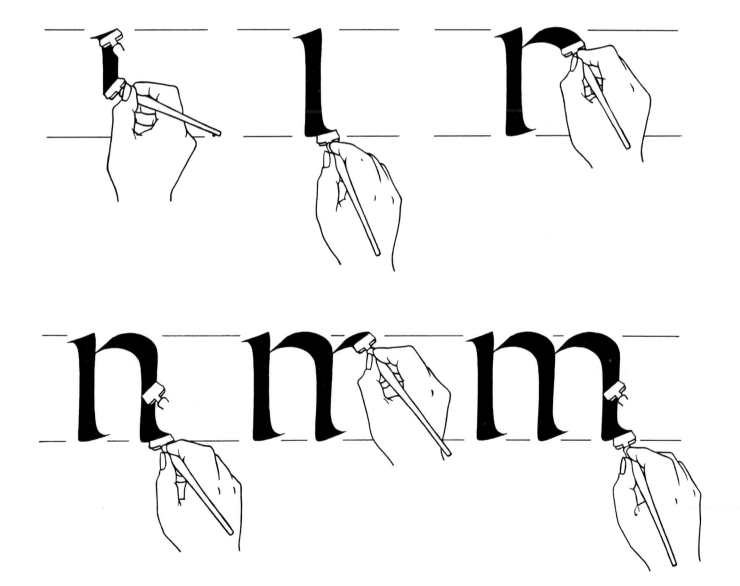

n

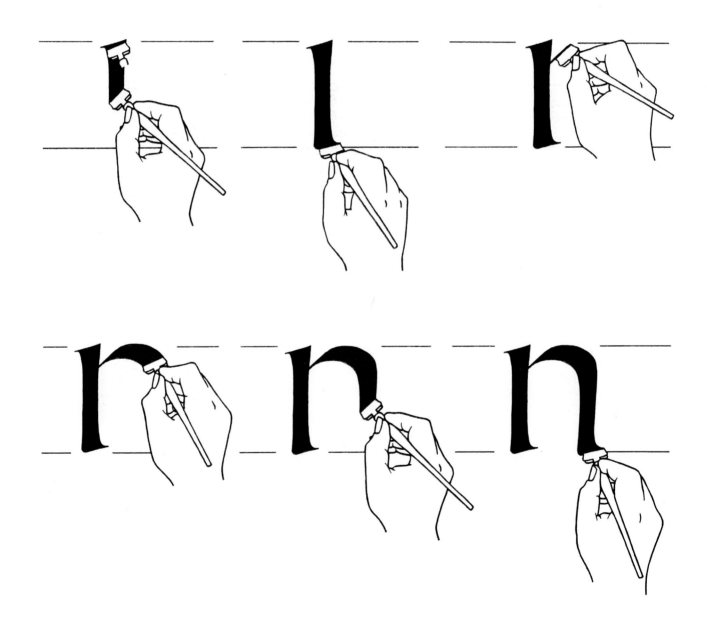

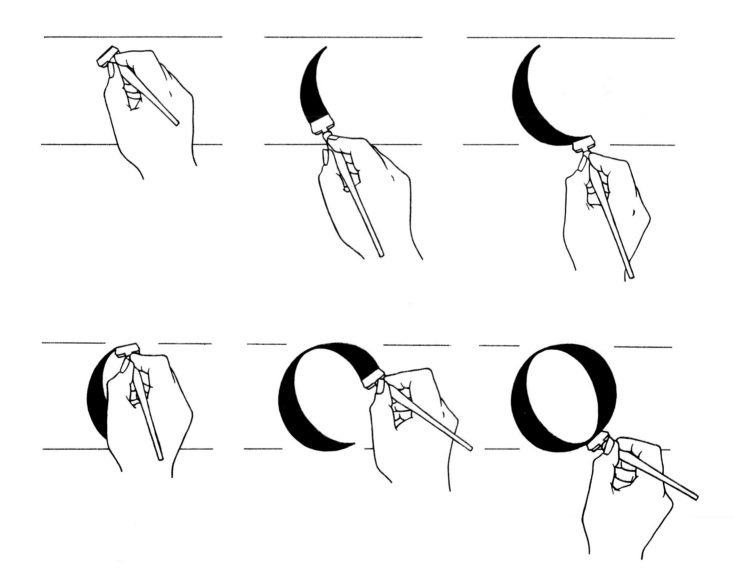

P

i l r

n p p

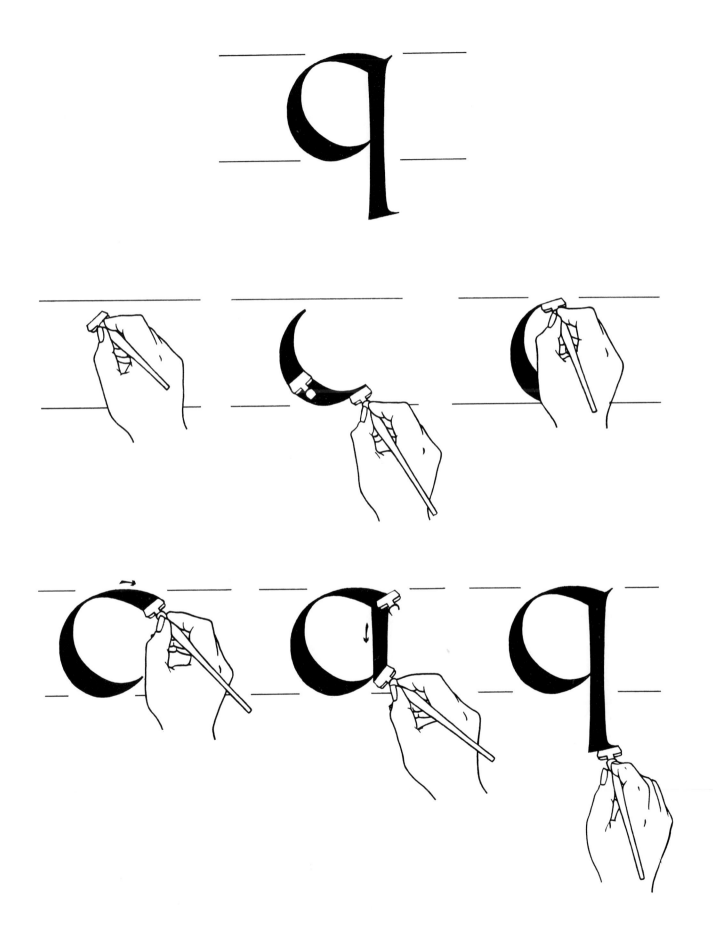

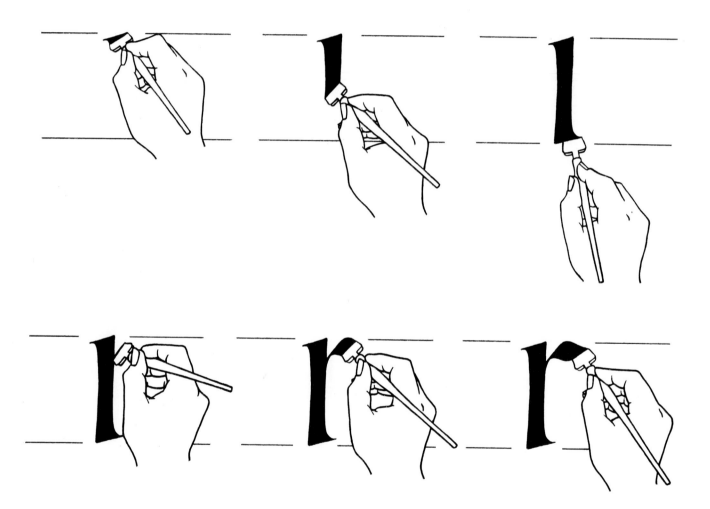

S

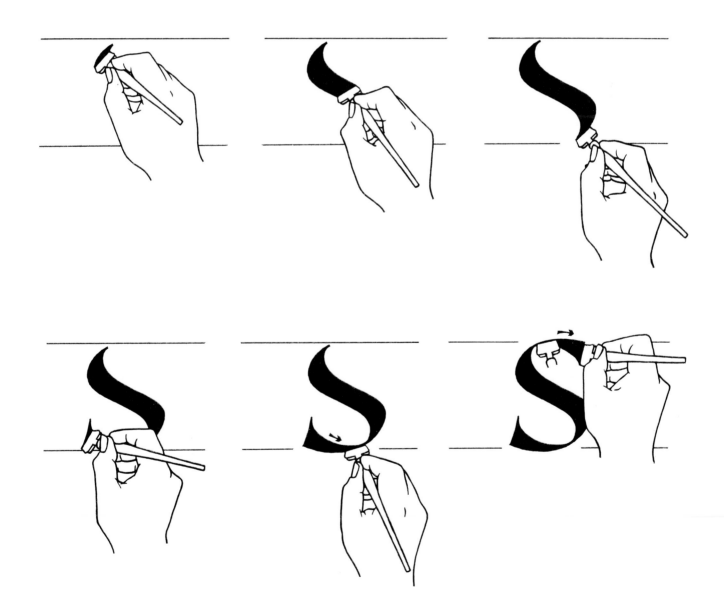

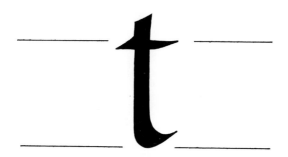

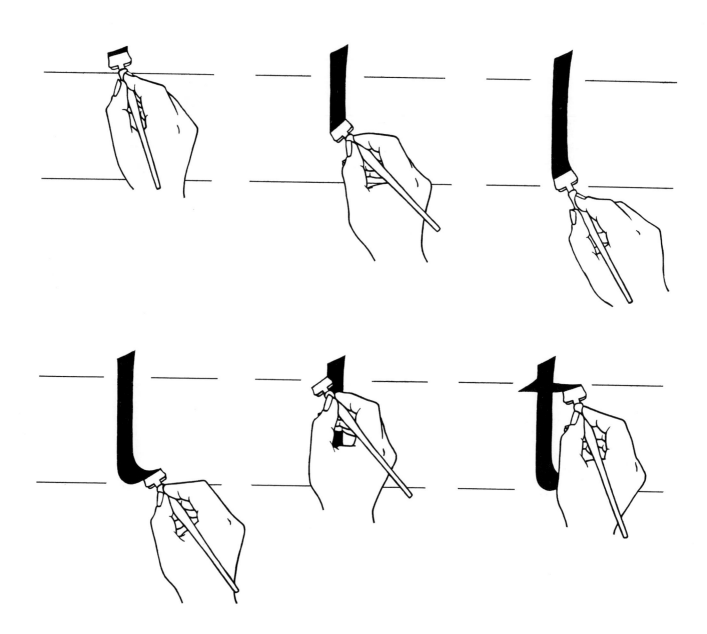

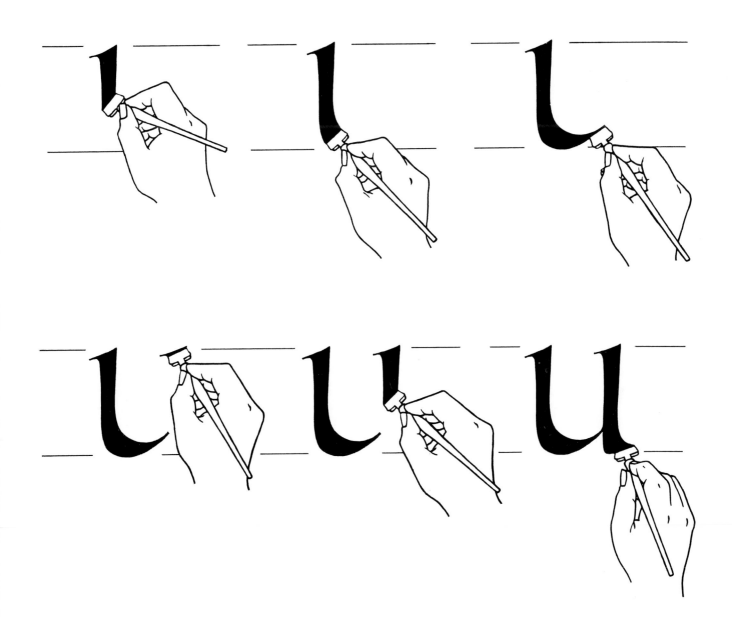

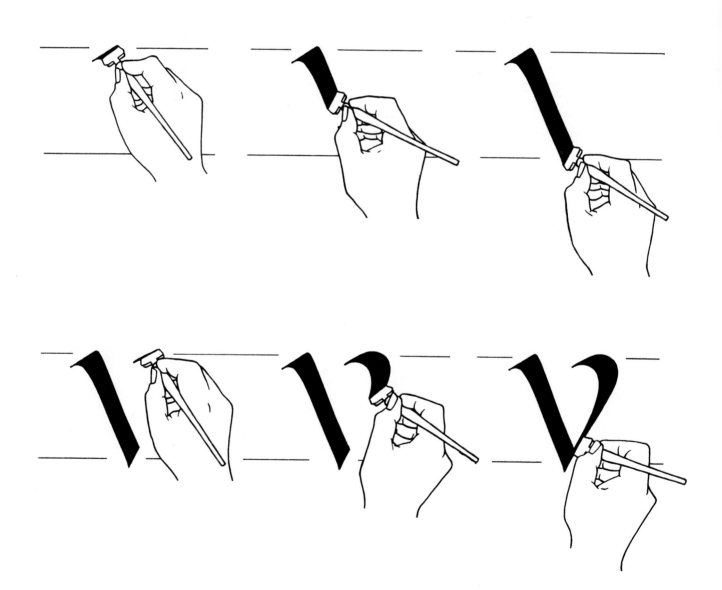

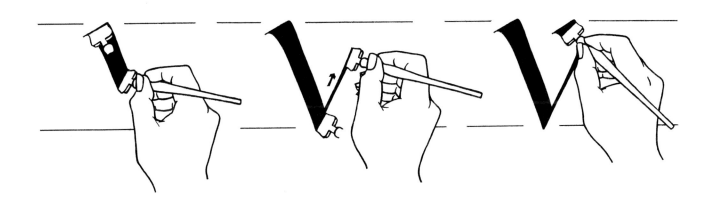

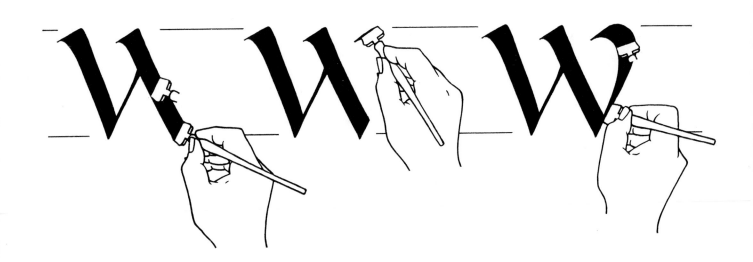

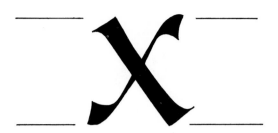

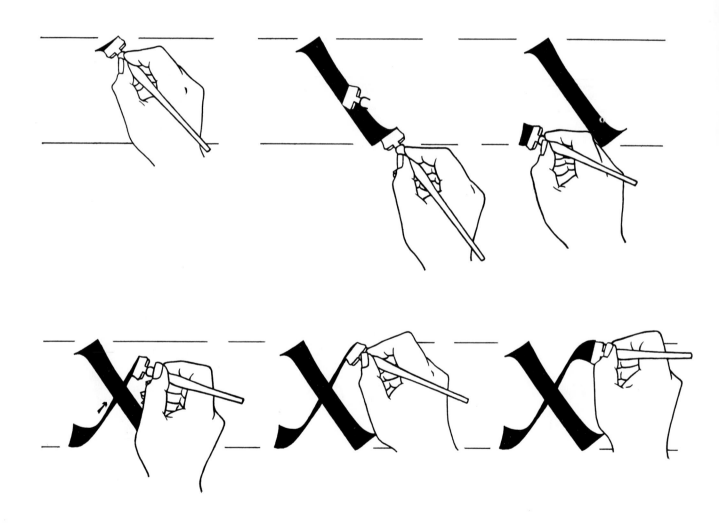

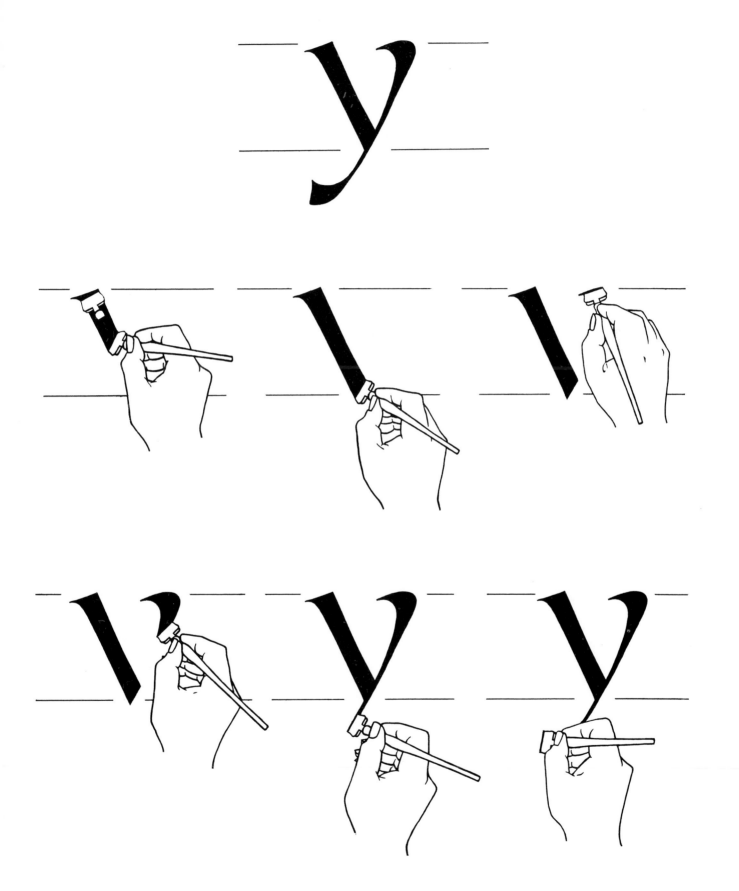

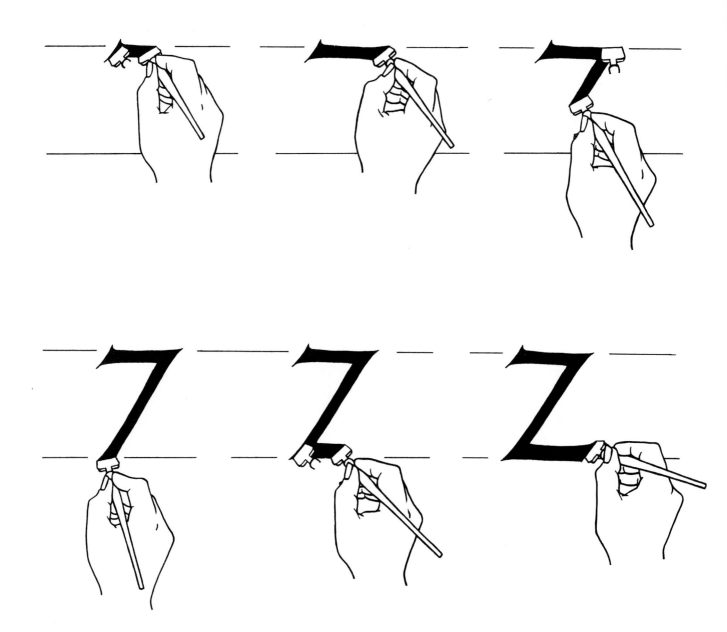

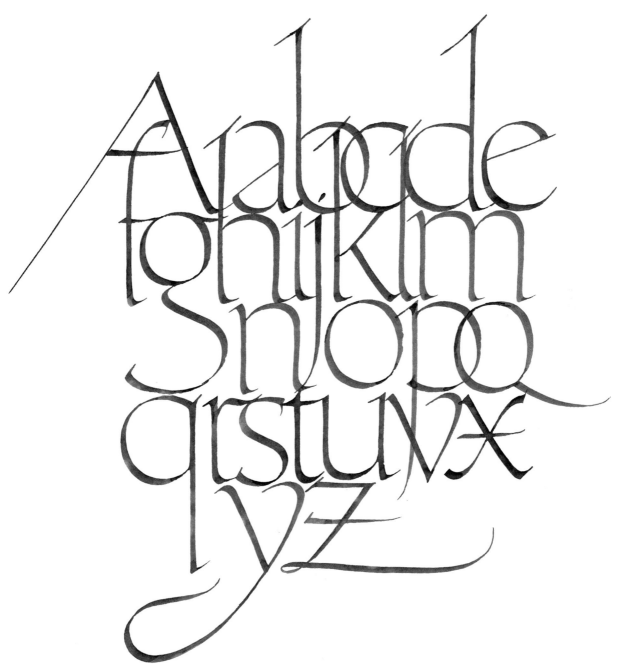

Arthur Baker 1981

abcdef
opqrstu

Arthur Baker 1981

hijklmn
svwwxyz

aabbccdde
mnnoopp
rsstuuuuikv

arthur Baker 1981

64

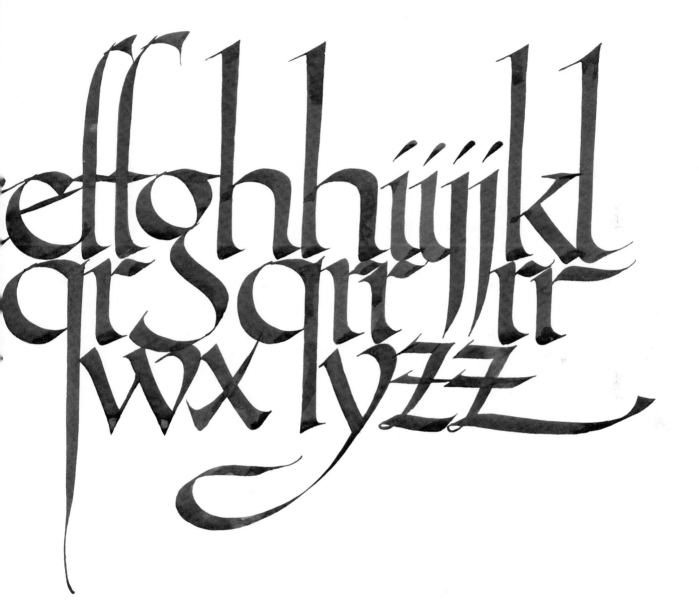

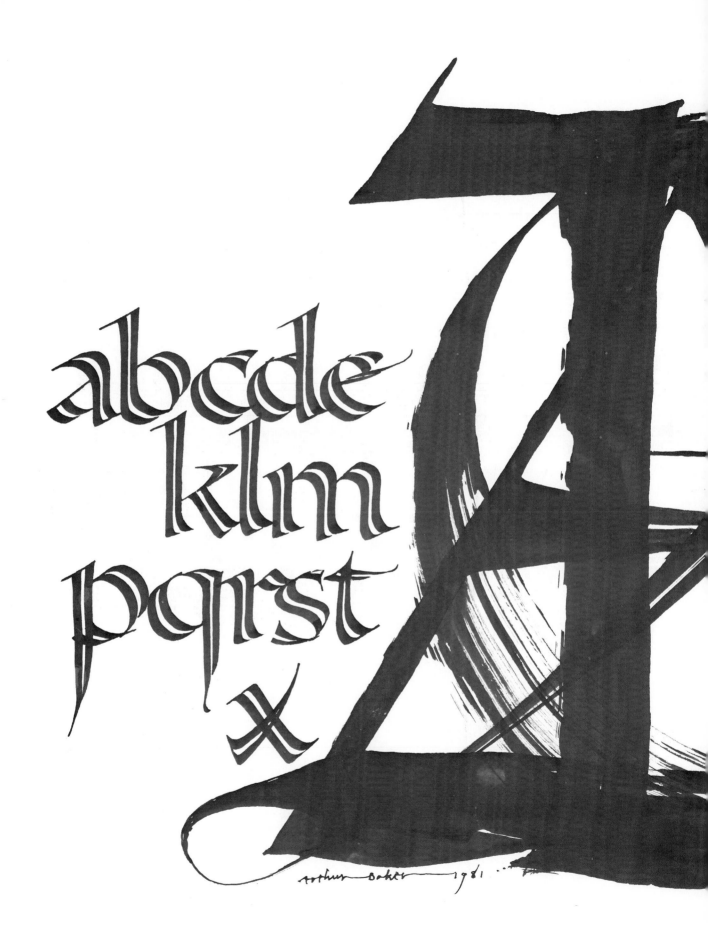

abcde
klm
pqrst
x

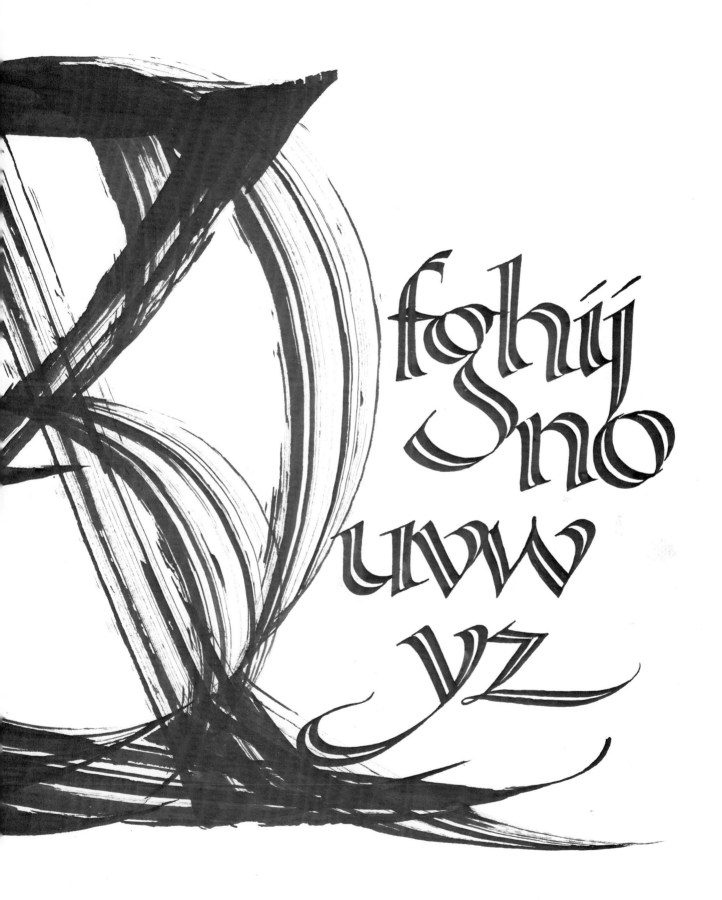

ABCDE
MNOPC
WX

GHIJKL
RSTUV
YZ

A———— B————— 1982

abcde
mnop
u v w

fghijkl
Spbrst
xy z

AB 1982

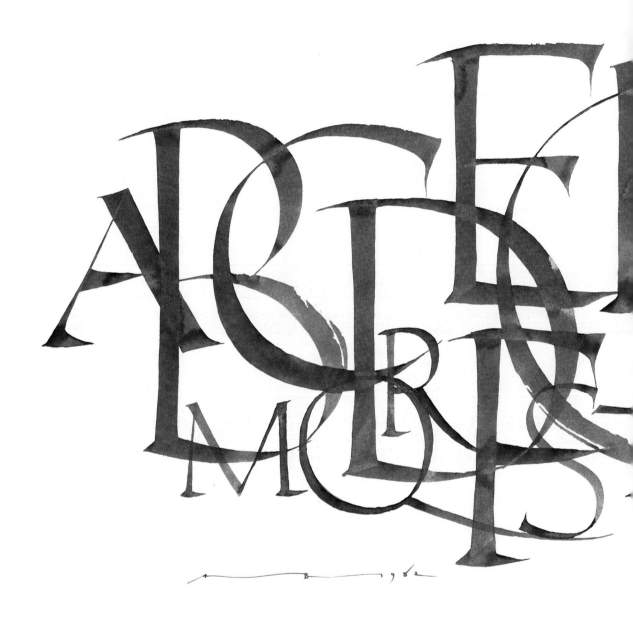

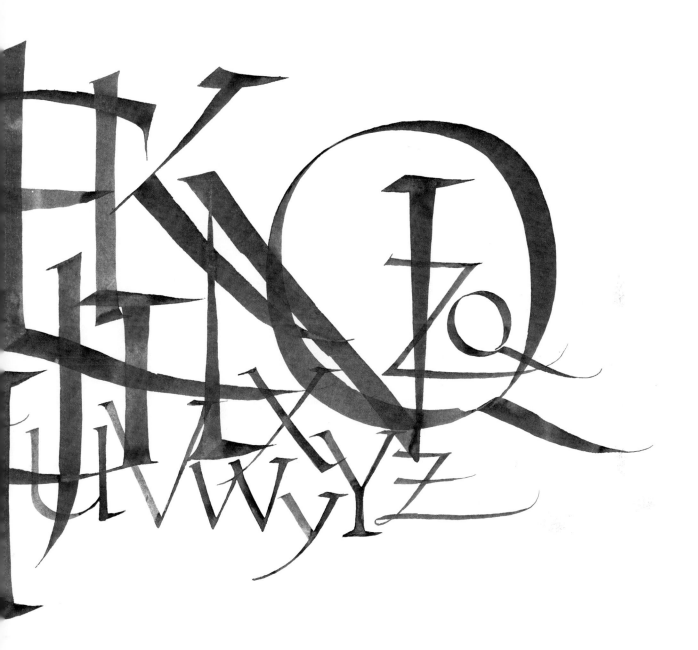

Aabcdefghrstuv

Arthur Baker 1981

ijklmnopqr
wxyz

ABCDEFG HIJK
W
X

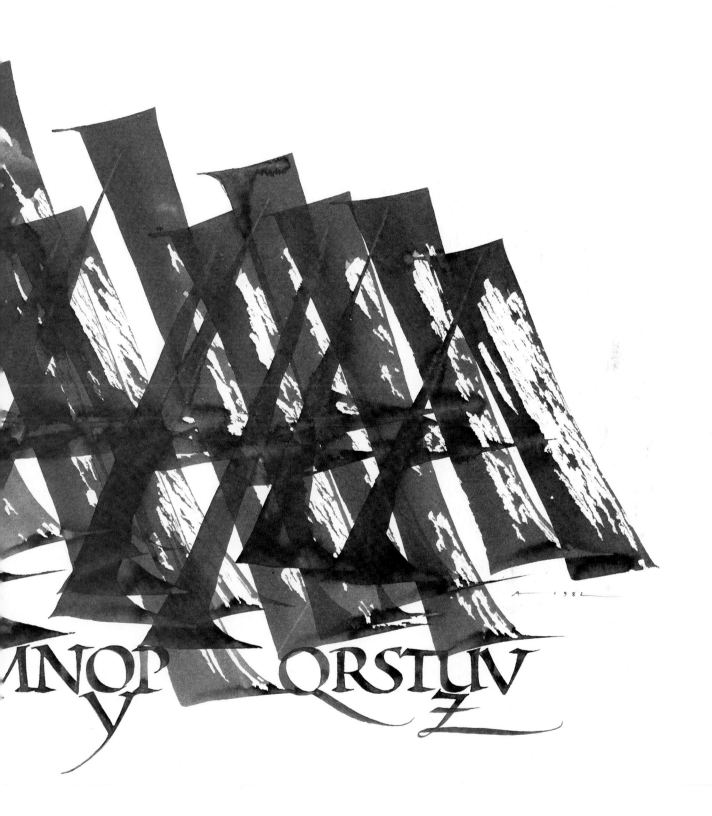

MNOP QRSTUV
Y Z

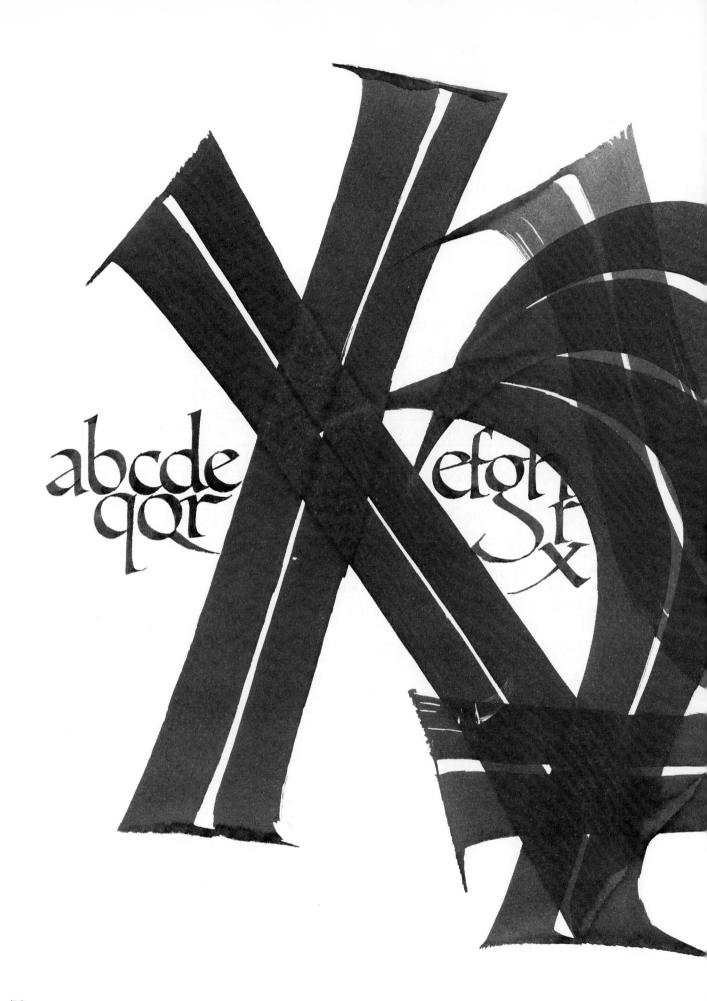

abcde
qor

efgr
st
x

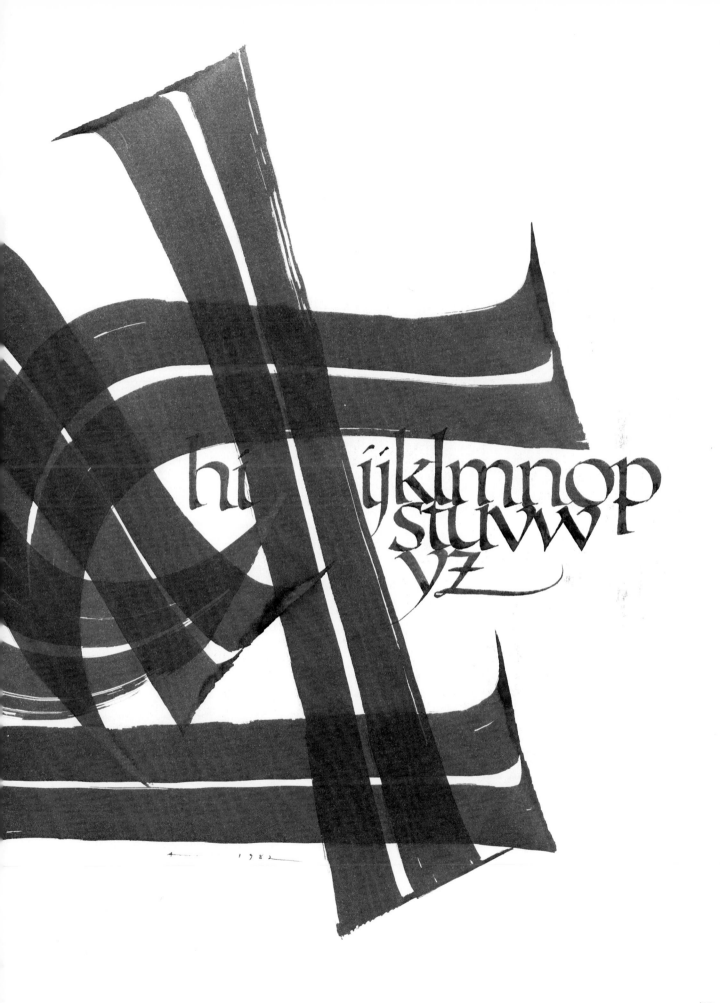

ABCDEFGHIJKL
MNOPQRSTUV
X Y Z

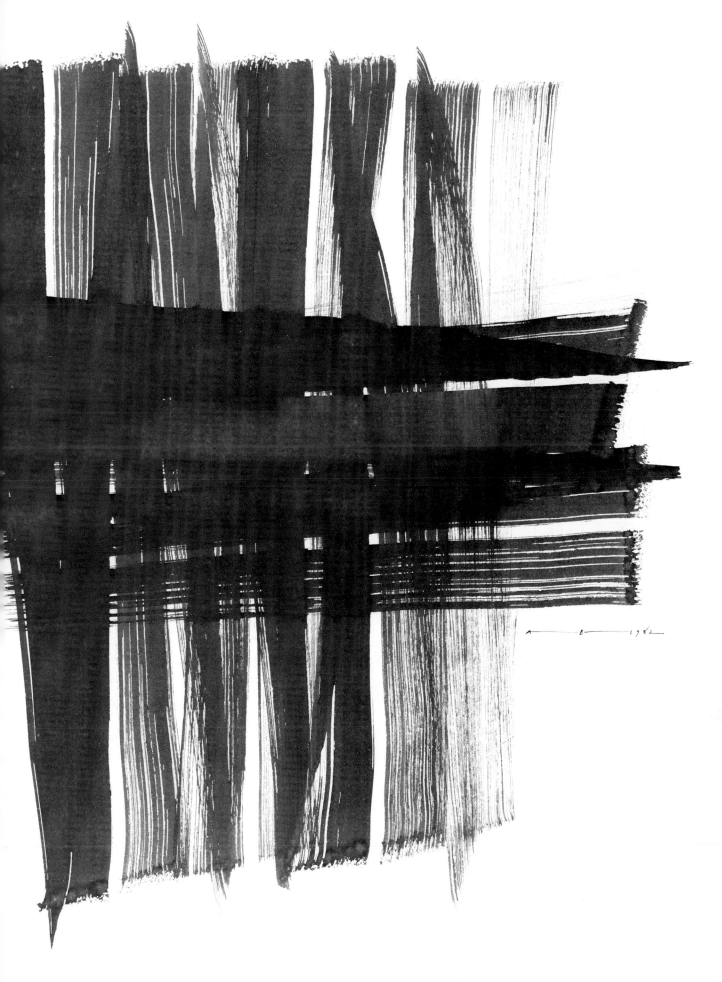

81

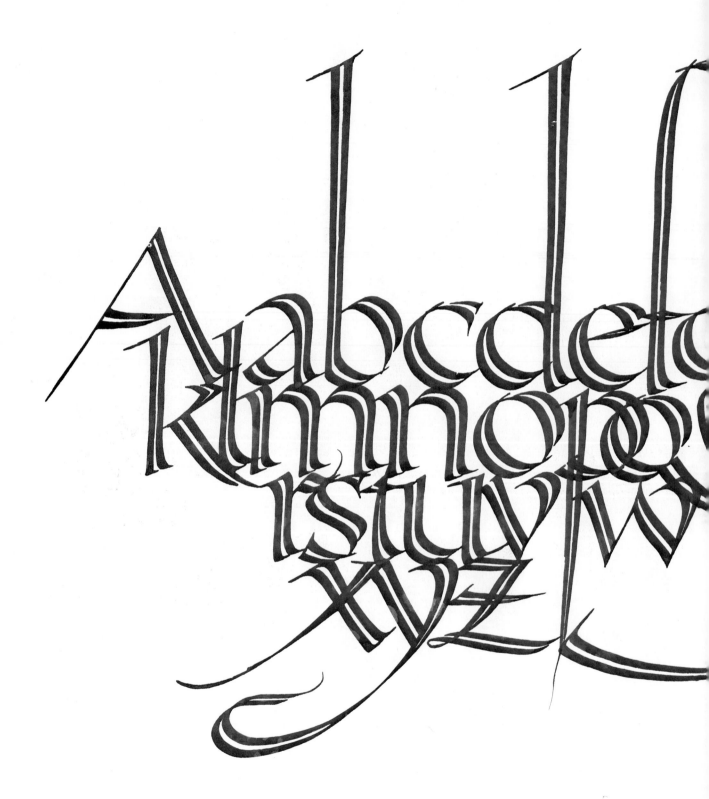

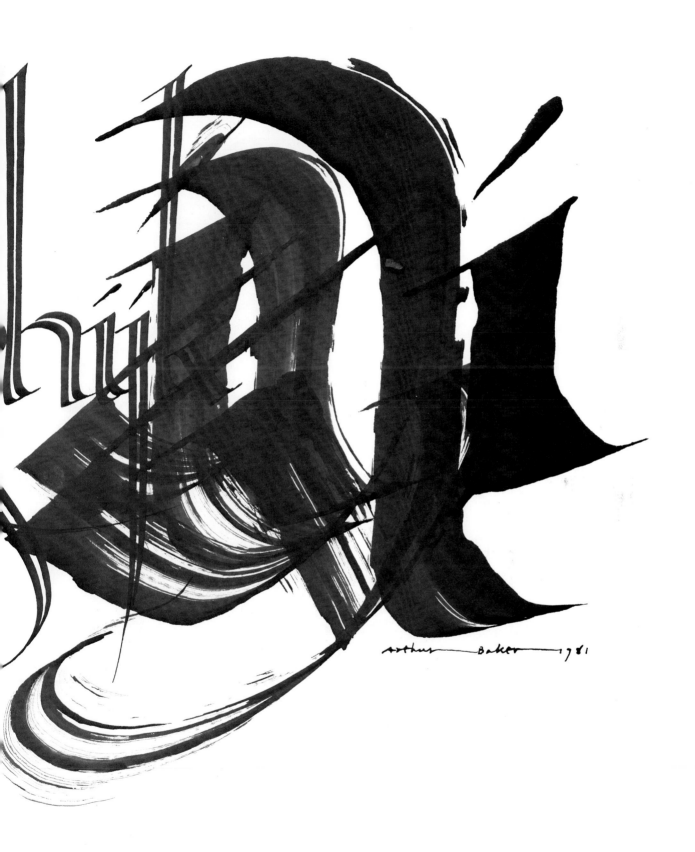

arthur Baker 1981

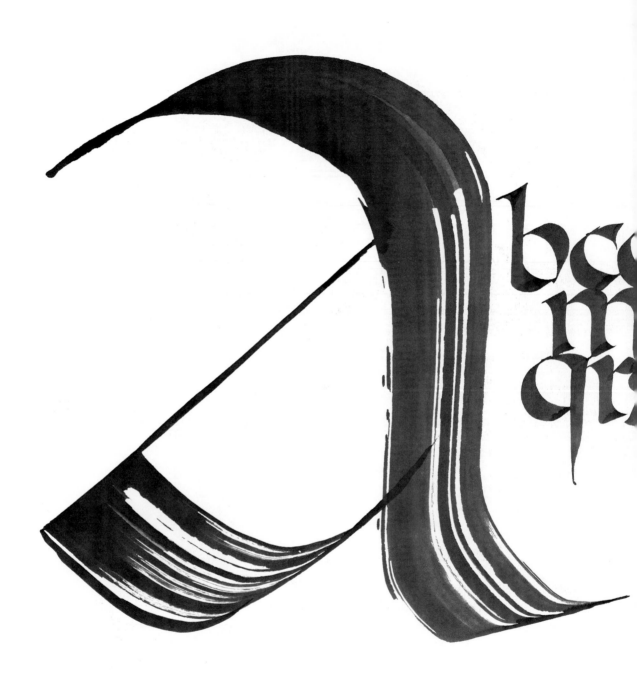

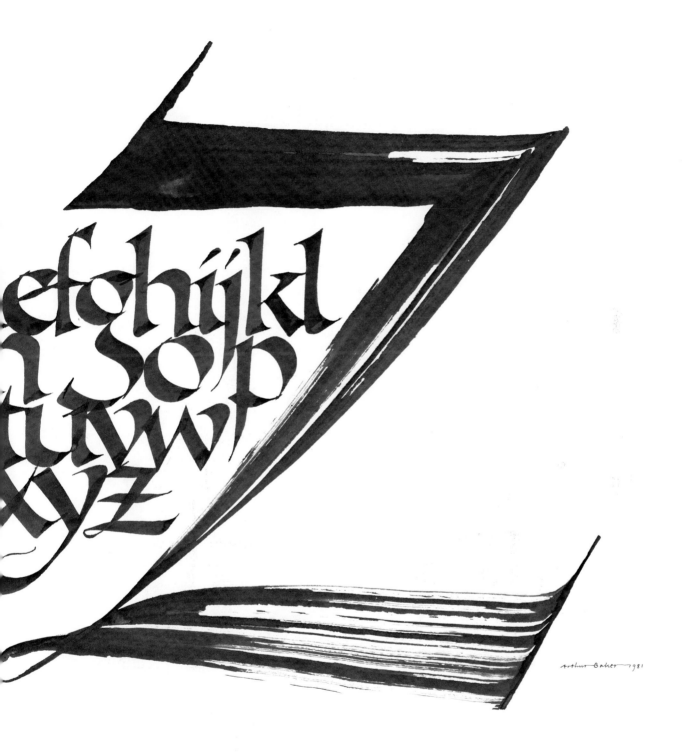

efghijkl
n sop
tuvwp
xyz

Arthur Baker 1981

85

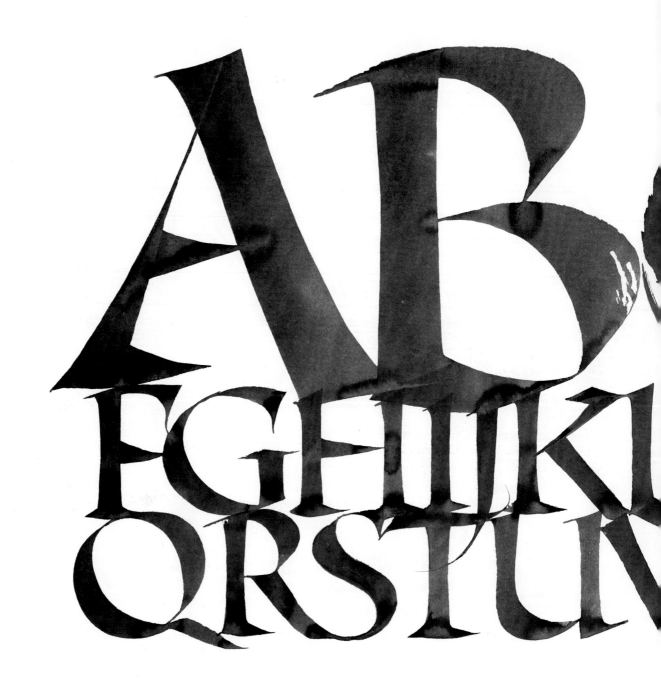

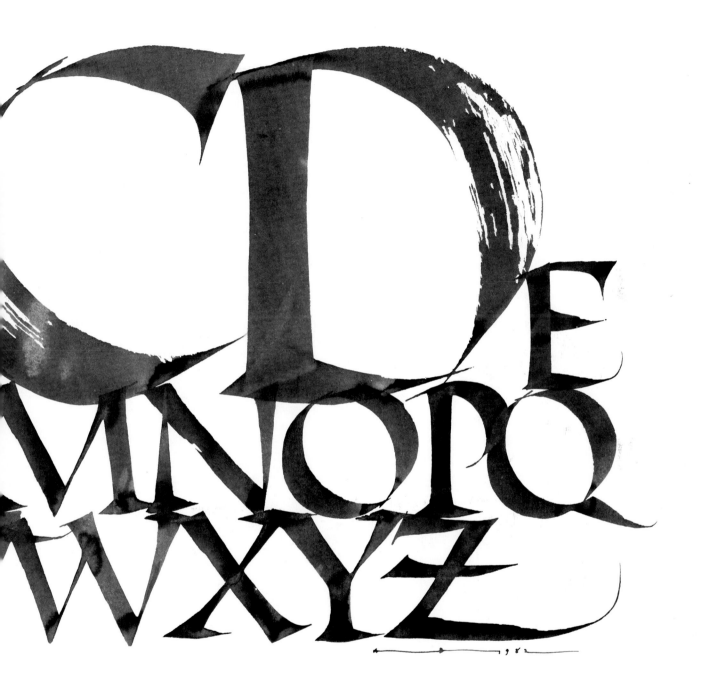

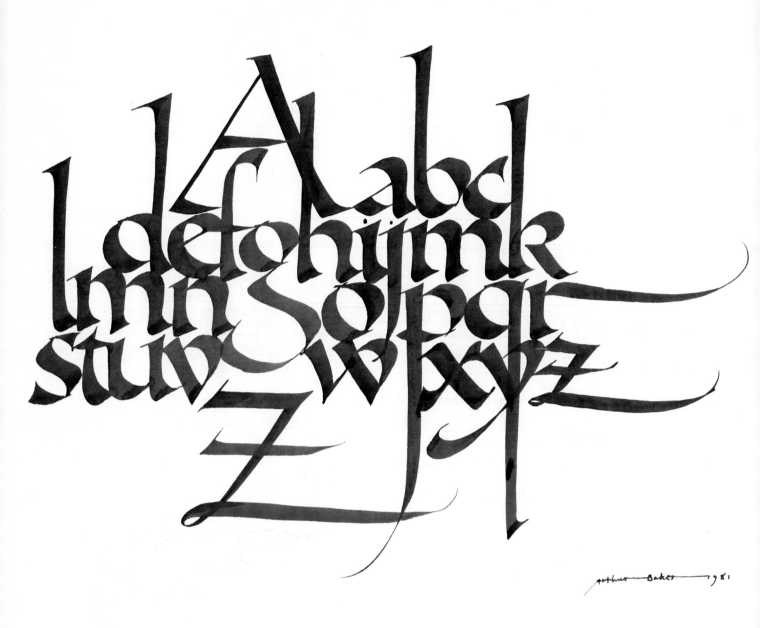

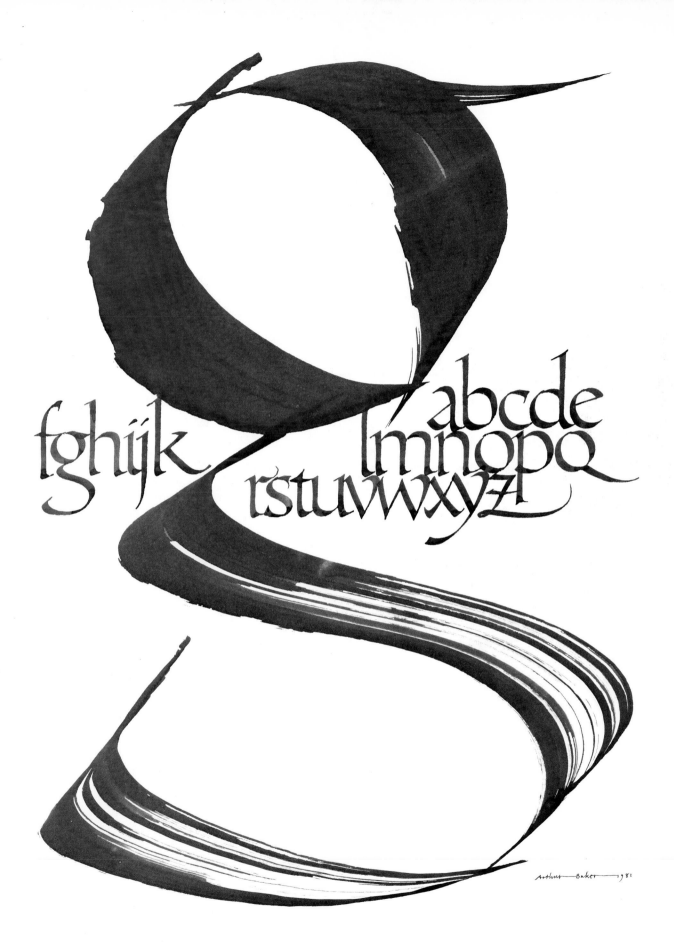

abcde
fghijk lmnopq
rstuvwxyz

Arthur Baker 1981

Aabcdefghijklmnopqr
stuvwxyz

arthur—Baker 1981